Sanctuary

by Tanika Gupta

TRANSFORMATION

29 April–21 September 2002

The Lyttelton *Transformation* project is vital to my idea of the National Theatre because it both celebrates and challenges our identity. What do we want the National to be? We must draw on our heritage, on our recent past, and on the talent of the next generation. I want a thriving new audience, including a body of young people under 30 with a theatre-going habit, a new generation of artistic and administrative talent committed to taking the National forward and a realization of the varied potential within this glorious building.

Trevor Nunn Director of the National Theatre

Transformation is thirteen world premieres, hosted in two new theatre spaces, with special low ticket prices. The National's most traditional auditorium, the Lyttelton, has been transformed by a sweep of seats from circle to stage to create a new intimacy between actor and audience. At the same time the Loft has been created – a fully flexible 100-seat theatre. *Transformation* will introduce new generations of theatre makers and theatre audiences to one of the most exciting theatres in the world.

Mick Gordon Artistic Associate
Joseph Smith Associate Producer

Transformation has received major creative input from the Studio – the National Theatre's laboratory for new work and its engine room for new writing – and celebrates the Studio's continuing investment in theatre makers.

Sanctuary

by Tanika Gupta

In order of speaking

Sebastian Cruz	EDDIE NESTOR
Michael Ruzindana	LEO WRINGER
Kabir Sheikh	NITIN GANATRA
Jenny Catchpole	SUSANNAH WISE
Ayesha Williams	SARAH SOLEMANI
Margaret Catchpole	BARBARA JEFFORD
Director	HETTIE MACDONALD
Designer	JON BAUSOR
Lighting Designer	PETE BULL
Sound Designer	RICH WALSH
Company Voice Work	PATSY RODENBURG & KATE GODFREY
Assistant Director	Ruth Carney
Production Manager	Katrina Gilroy
Stage Manager	Emma B Lloyd
Deputy Stage Manager	Thomas Vowles
Assistant Stage Manager	Mary O'Hanlon
Fights	Terry King
Costume Supervisor	Frances Gager, assisted by Louise Bratton
Casting	Gabrielle Dawes & Hannah Miller

THE PLAY IS SET IN **2002**, WITHIN THE GROUNDS OF A CHURCHYARD

OPENING: Loft 29 July 2002

Copies of this cast list in braille or large print are available at the Information Desk

NITIN GANATRA

KABIR SHEIKH

Nitin Ganatra trained at the University of Bristol and went on to spend two years under the tutelage of Jerzy Grotowski. He is also trained in classical mime and several martial art forms. **Theatre** includes *Haroun and the Sea of Stories* (National); *To The Green Fields Beyond* (Donmar Warehouse); *Blessings* (Old Red Lion Theatre). **Television:** *Being April, Rescue Me, The Jury, Me and Mrs Jones, Randell and Hopkirk Deceased* and *Kumbh Mela.* **Film:** *Pure, Guru In Seven, Secrets and Lies, Inferno, Love Doctor, Stag, This Bastard Business.*

BARBARA JEFFORD

MARGARET CATCHPOLE

Barbara Jefford can claim to be our most experienced Shakespearean actress, playing leading roles in 54 productions of his plays since 1949 with companies such as the National Theatre, Shakespeare Memorial Theatre, RSC, Old Vic, Prospect, Bristol Old Vic, Oxford Playhouse, The Almeida and The Crucible, Sheffield, where she has just played Queen Margaret in *Richard III* with Kenneth Branagh. At the National she has appeared in *Hamlet, Tamburlaine The Great, Six Characters in Search of an Author, Fathers and Sons* and *Ting Tang Mine.* She has appeared in the West End and on Broadway, in many films and TV productions, and worked extensively in radio since 1946.

EDDIE NESTOR

SEBASTIAN CRUZ

Some of his many **theatre** credits include, most recently *One Dance Will Do* (Theatre Royal, Stratford East); *A Streetcar Named Desire* (Bristol Old Vic) and *Local Boy* (Hampstead). Recently worked on an episode of *EastEnders* and may be recognised from numerous other television and film appearances including *The Royal McCoy* (3 series), *Desmonds* and *Casualty* (3 series).

SARAH SOLEMANI

AYESHA WILLIAMS

Now 19, Sarah Solemani has been a member of the National Youth Theatre for three years. She has performed in various NYT productions including *AgeSexLocation* at the Lyric Theatre, Hammersmith. She made her West End Debut as Elaine Robinson in *The Graduate.* She has recently filmed the BBC military drama *Red Cap,* showing this Autumn. She is working with the National Theatre in her 'gap' year, and in October, will be reading Social and Political Science at Cambridge University.

SUSANNAH WISE

JENNY CATCHPOLE

Theatre credits include *The Prime of Miss Jean Brodie* (NT); *Where Do We Live* (Royal Court); *Life After George* (West End); *Three Sisters, Heartbreak House* (Chichester Festival Theatre); *The Critic, The Dispute, The Candidate* (Royal Exchange, Manchester); *Golem* (National Studio); *Hay Fever* (Crucible, Sheffield); *Featuring Loretta* (Hampstead). **Television** includes *The Strawberry Tree, As You Like It Rehearsal, A Nice Cup of Tea, Class Act, Casualty, Bliss, Eskimo Day, The Bill, Dalziel & Pascoe, The Tenant of Wildfell Hall, Staying Alive, Where The Heart Is, Faith In The Future, In A Land of Plenty, Kavanagh QC.* **Film** includes *An Ideal Husband* and *Britannic.*

LEO WRINGER

MICHAEL RUZINDANA

Classical work includes Eros in *Antony and Cleopatra* (NT); Duke of Ephesus and Dr Pinch in *The Comedy of Errors* (RSC); King of Athens in Deborah Warner's *Medea* (Abbey, Dublin & Queen's Theatre London); title role in *Woyzeck* (Bristol Old Vic); Mirabell in *The Way of the World* (Theatre Royal, York); Camillo in *The Winter's Tale* (Complicite); *More Grimm Tales* (Young Vic). Other Shakespeare roles include Autolycus, Banquo, Casca, Puck, Launcelot Gobbo and Rosencrantz. In 1996, the title role in *Othello* (Watermill for Edward Hall). In 1999 he understudied and went on as Hamlet at Tokyo Globe (Laurence Boswell for the Young Vic). In 2002 he played Othello at Southwark Playhouse, directed by Spencer Hinton.

TANIKA GUPTA
AUTHOR

Tanika Gupta was the Pearson's Writer in Residence at the Royal National Theatre between 2000 and 2001. Her stage plays include *Voices on the Wind* (NT Studio 1995); *Skeleton* (Soho Theatre Company 1997); *A River Sutra*, an adaptation of Gita Mehta's novel (for Indosa/NT Studio, Three Mill Island Studios 1997); *On The Couch With Enoch* (for The Red Room, 1998); *The Waiting Room* (NT Cottesloe 2000, winner of the John Whiting Award) and a translation of Brecht's *The Good Woman of Setzuan* (NT Education, 2001). She has also written over 20 original plays for radio. TV: *EastEnders, Grange Hill, London Bridge, The Bill.* Film: *Flight, Bideshi, The Fiancée, The Lives of Animals* (BBC adaptation of J M Coetzee's novel).

HETTIE MACDONALD
DIRECTOR

Theatre: *The Thickness of Skin, Talking in Tongues, A Jamaican Airman Foresees His Death, The Plague Year, William* (Royal Court); *The Storm* (Almeida); *Beautiful Thing* (Bush, Donmar, Duke of York's); *The Madman of the Balconies* (Gate); *Yiddish Trojan Women* (Soho Theatre Co); *All My Sons* (Oxford Stage Co); *Once in a While The Odd Thing Happens, Road, The Slicing Edge, Absent Friends, The Scarlet Pimpernel, A View from the Bridge, A Doll's House, Who's Afraid of Virginia Woolf?, Three Sisters* (all as Assoc. Director, Wolsey Theatre, Ipswich); *A Pricksong for the New Leviathan* (Old Red Lion); *A Midsummer Night's Dream* (Chester); *Brighton Beach Memoirs* (Salisbury); *Shamrocks and Crocodiles* (Liverpool); *Leavetaking* (WPT). Opera: *Hey Persephone!* (Almeida/ Aldeburgh). TV: *In a Land of Plenty.* Film: *Beautiful Thing.*

JON BAUSOR
DESIGNER

Jon Bausor trained at Exeter College of Art; New College, Oxford (Choral Scholar); Motley Theatre Design Course; finalist in this year's Linbury Prize for Stage Design. Theatre designs include *The Soul of Chien-Nu Leaves Her Body; The Blacks* (Young Vic Studio); *Sirens* (Gielgud Theatre, RADA); *The Art of Success; Ghosts in the Cottonwoods* (Arcola Theatre); *Oleanna* (Scottish tour); *Troy* (NT Studio). Opera design includes *Queen of Spades* (Edinburgh Festival Theatre); *King Arthur* (New Chamber Opera) and *Cosi Fan Tutte* (Handmade Opera).

PETE BULL
LIGHTING DESIGNER

Pete Bull has lit shows as diverse as stand-up comedy and Greek tragedy, in venues ranging from upstairs in a pub to an open-air amphitheatre, in places as far apart as Vancouver and Clacton. He recently did the re-lights for the National's world tour of *Hamlet*, including a unique opportunity to light the show in Elsinore Castle, and lit *Free* and *Life after Life* in the Loft.

RICH WALSH
SOUND DESIGNER

Previous sound designs include: *The Shadow of a Boy, Free, Sing Yer Heart Out for the Lads, The Walls* (National), *Exposure, Under The Blue Sky, On Raftery's Hill, Sacred Heart, Trust, Choice* (Royal Court); *Julie Burchill is Away* (Soho Theatre); *50 Revolutions* (Whitehall); *The Boy Who Left Home, The Nation's Favourite* (UK tours), *Yllana's 666* (Riverside Studios); *Strike Gently Away From Body, Blavatsky* (Young Vic Studio); *Body And Soul, Soap Opera, The Baltimore Waltz* (Upstairs At The Gatehouse), *Small Craft Warnings* (Pleasance); *The Taming of the Shrew, Macbeth* (Japanese tour); *Dirk, Red Noses* (Oxford Playhouse); *The Wizard of Oz, The Winter's Tale* (Old Fire Station, Oxford).

RUTH CARNEY
ASSISTANT DIRECTOR

Ruth Carney studied at the University of Sheffield and at the Russian Theatre Academy, Moscow and Middlesex University gaining an MA in Theatre Directing. She was Artistic Director of The Latchmere and participated on the National Studio's Directors' Course. She has recently been associate artist to Fiona Laird on *War Cabaret*. Directing credits include *The Lemon Princess* (Caird Company @ NT), *Tales from Ovid* (Ellen Terry Studio), *Family* (New End), *Gut Girls* (Cockpit), *Company* (Greenwich Playhouse & Palace Theatre), *Mina Laury* (Brighton Festival) and *Emma* (Norwich Playhouse).

PRODUCTION CREDITS
Thanks to Salilsuprati.

The Loft Theatre was created with the help of the Royal National Theatre Foundation.

The Transformation season is supported by Edward and Elissa Annunziato, Peter Wolff Theatre Trust, and by a gift from the estate of André Deutsch.

Many of the projects in the Transformation season were developed in the National Theatre Studio.

ON WORD graphics designed by typographer Alan Kitching using original wood letters.

The National's workshops are responsible for, on these productions: Armoury; Costume; Props & furniture; Scenic construction; Scenic painting; Wigs

TRANSFORMATION SEASON TEAM (Loft)
ARTISTIC ASSOCIATE Mick Gordon
ASSOCIATE PRODUCER Joseph Smith
ADMINISTRATOR Sarah Nicholson
LOFT THEATRE DESIGNER Will Bowen
FRONT OF HOUSE DESIGNER Jo Maund
FRONT OF HOUSE DESIGN PRODUCTION MANAGER Gavin Gibson
LITERARY MANAGER Jack Bradley
PLANNING PROJECT MANAGER Paul Jozefowski
RESIDENT DIRECTOR – LOFT Paul Miller
PRODUCTION CO-ORDINATOR Katrina Gilroy
PRODUCTION MANAGER – LOFT REALISATION Jo Maund
PRODUCTION ASSISTANTS – LOFT REALISATION Alan Bain and Gavin Gibson
LOFT LIGHTING REALISATION & TECHNICIANS Mike Atkinson, Steve Barnett,
 Pete Bull, Huw Llewellyn, Cat Silver
LOFT SOUND REALISATION Adam Rudd, Rich Walsh
LOFT STAGE TECHNICIANS Danny O'Neill, Stuart Smith
MODEL MAKERS Aaron Marsden, Riette Hayes-Davies
GRAPHIC DESIGNERS Stephen Cummiskey, Patrick Eley
PROGRAMME EDITOR Dinah Wood
PRESS Lucinda Morrison, Mary Parker, Gemma Gibb
MARKETING David Hamilton-Peters
PRODUCTION PHOTOGRAPHER Sheila Burnett
THEATRE MANAGER John Langley

Thanks to the following people who were part of the original Lyttelton Development Group: Ushi Bagga, Alice Dunne, Annie Eves-Boland, Jonathan Holloway, Gareth James, Mark Jonathan, Holly Kendrick, Paul Jozefowski, Angus MacKechnie, Tim Redfern, Chris Shutt, Matt Strevens, Jane Suffling, Nicola Wilson, Dinah Wood, Lucy Woollatt

NATIONAL THEATRE BOOKSHOP
The National's Bookshop in the Main Entrance foyer on the ground floor stocks a wide range of theatre-related books. Texts of all the plays in the Loft during the Transformation season, and of the plays in *Channels (France)* are available from the NT Bookshop at £2. T: 020 7452 3456; www.nationaltheatre.org.uk/bookshop

TRANSFORMATION SEASON

IN THE LYTTELTON

A co-production between the National Theatre & Théâtre National de Chaillot
The PowerBook . 9 May–4 June
from a novel by Jeanette Winterson
devised by Jeanette Winterson, Deborah Warner & Fiona Shaw
Director Deborah Warner

A Prayer for Owen Meany . 10–29 June
a novel by John Irving
adapted by Simon Bent
Director Mick Gordon

A collaboration between the National Theatre & Trestle Theatre Company
The Adventures of the Stoneheads . 4–13 July
written & directed by Toby Wilsher

A collaboration between the National Theatre & Mamaloucos Circus
The Birds . 22 July–14 August
by Aristophanes, in a new version by Sean O'Brien
Director Kathryn Hunter

Play Without Words . 20 August–14 September
devised & directed by Matthew Bourne

IN THE LOFT

Sing Yer Heart Out for the Lads 29 April–15 May
by Roy Williams
Director Simon Usher

Free . 20 May–8 June
by Simon Bowen
Director Thea Sharrock

Life After Life . 28 May–8 June
a reportage play by Paul Jepson & Tony Parker
Director Paul Jepson

The Shadow of a Boy . 13–29 June
by Gary Owen
Director Erica Whyman

The Mentalists . 4–20 July
by Richard Bean
Director Sean Holmes

Sanctuary . 25 July–10 August
by Tanika Gupta
Director Hettie Macdonald

The Associate . 15–31 August
by Simon Bent
Director Paul Miller

Closing Time . 5–21 September
by Owen McCafferty
Director James Kerr

NATIONAL THEATRE STUDIO &
TRANSFORMATION

All the plays in the LOFT are co-produced with the National Theatre Studio. The Studio is the National's laboratory for research and development, providing a workspace outside the confines of the rehearsal room and stage, where artists can experiment and develop their skills.

As part of its training for artists there is an on-going programme of classes, workshops, seminars, courses and masterclasses. Residencies have also been held in Edinburgh, Vilnius, Belfast and South Africa, enabling artists from a wider community to share and exchange experiences.

Central to the Studio's work is a commitment to new writing. The development and support of writers is demonstrated through play readings, workshops, short-term attachments, bursaries and sessions with senior writers. Work developed there continually reaches audiences throughout the country and overseas, on radio, film and television as well as at the National and other theatres. Most recent work includes the award-winning plays *Further than the Furthest Thing* by Zinnie Harris (Tron Theatre, Glasgow; Traverse, Edinburgh, and NT), *The Waiting Room* by Tanika Gupta (NT) and *Gagarin Way* by Gregory Burke (in association with Traverse, Edinburgh; NT; and at the Arts Theatre), *The Walls* by Colin Teevan (NT), *Accomplices* by Simon Bent, *Mr England* by Richard Bean (in association with Sheffield Theatres) and *The Slight Witch* by Paul Lucas (in association with Birmingham Rep), as well as a season of five new plays from around the world with the Gate Theatre, and *Missing Reel* by Toby Jones at the Traverse during the Edinburgh Festival 2001. *Gagarin Way* and *Further than the Furthest Thing* were part of SPRINGBOARDS – a series of partnerships created by the Royal National Theatre Studio with other theatres, enabling work by emerging writers to reach a wider audience.

Direct Action, a collaboration between The Studio and the Young Vic, is an initiative that provides young directors with an opportunity to work on the main stage of the Young Vic. Two plays were co-produced in the autumn of 2001: Max Frisch's *Andorra*, directed by Gregory Thompson; and David Rudkin's *Afore Night Come*, directed by Rufus Norris, who won the Evening Standard award for Best Newcomer for this production.

For the Royal National Theatre Studio

HEAD OF STUDIO	Sue Higginson
STUDIO MANAGER	Matt Strevens
TECHNICAL MANAGER	Eddie Keogh
INTERNATIONAL PROJECTS MANAGER	Philippe Le Moine

Royal National Theatre
South Bank, London SE1 9PX
Box Office: 020 7452 3000
Information: 020 7452 3400

Registered Charity No: 224223

The chief aims of the National, under the direction of Trevor Nunn, are to present a diverse repertoire, embracing classic, new and neglected plays; to present these plays to the very highest standards; and to give audiences a wide choice.

All kinds of other events and services are on offer – short early-evening Platform performances; work for children and education work; free live entertainment both inside and outdoors at holiday times; exhibitions; live foyer music; backstage tours; bookshops; plenty of places to eat and drink; and easy car-parking. The nearby Studio acts as a resource for research and development for actors, writers and directors.

We send productions on tour, both in this country and abroad, and do all we can, through ticket-pricing, to make the NT accessible to everyone.

The National's home on the South Bank, opened in 1976, contains three separate theatres: the Olivier, the Lyttelton, and the Cottesloe and – during Transformation – a fourth: the Loft. It is open to the public all day, six days a week, fifty-two weeks a year. Stage by Stage – an exhibition on the NT's history, can be seen in the Olivier Gallery.

First published in 2002 by Oberon Books Ltd.
(incorporating Absolute Classics)
521 Caledonian Road, London N7 9RH
Tel: 020 7607 3637 / Fax: 020 7607 3629

e–mail: oberon.books@btinternet.com
www.oberonbooks.com

A catalogue record for this book is available from the British Library.

ISBN: 1 84002 302 3

Printed in Great Britain by Antony Rowe Ltd., Chippenham.

This play is dedicated to
David Archer and Lin Coghlan

Characters

KABIR SHEIKH
Asian man, gardener and general handy man
in the church grounds

MICHAEL RUZINDANA
African man

SEBASTIAN CRUZ
middle-aged Afro-Caribbean man

JENNY CATCHPOLE
priest in her thirties

AYESHA WILLIAMS
fifteen-year-old mixed-race girl

MARGARET CATCHPOLE
elderly woman, Jenny's grandmother

ACT ONE

Scene 1

We are outdoors in the corner of a graveyard – a small Eden-like, neat patch of luscious green packed with shrubbery, ornate flowering plants (orchids) and small tubs of herbs etc. There is a wall to one side and a large tree, which overhangs the wall into the road outside. There is a shed to the other side and an old bench under the tree. The shed is covered in rambling roses and clematis, all in bloom. In the background we can see row upon row of gravestones, which stretch into the distance. A few bits of rubbish litter the otherwise beautiful garden.

It is a bright day. MICHAEL enters and sits on the bench beneath the tree, fashioning a piece of wood into a spoon. He works diligently whilst listening to the cricket commentary on the radio. MICHAEL is casually but smartly dressed. He looks completely engrossed in his work. SEBASTIAN wanders in and sits next to MICHAEL. He is shabbily dressed and dishevelled looking.

At first, he simply sits there in silence. Then he takes interest in what MICHAEL is doing.

SEBASTIAN: What're you working on?

MICHAEL: (*African accent.*) It is going to be a spoon.

SEBASTIAN: Ahhh…

SEBASTIAN watches him attentively.

You're good with your hands.

MICHAEL: My father was a carpenter.

SEBASTIAN: Family trade?

MICHAEL: Not really. He was good. He made all the furniture in our village. I just do it to pass the time.

SEBASTIAN looks around.

SEBASTIAN: I like it here.

MICHAEL: Yes.

SEBASTIAN: You like it here?

MICHAEL: Yes.

SEBASTIAN: Lots of dead people. Makes you feel lucky.

MICHAEL: Eh?

SEBASTIAN: That we're alive, man! However bad things are out there, at least we're not fucking six feet under. Know what I mean?

MICHAEL: (*Polite.*) I certainly know what you mean.

SEBASTIAN: Too right. Especially when you look at all those gravestones. Young people – half my age. Cut off in the prime of their lives.

MICHAEL continues with his work.

It's the baby ones that always get me. Tiny little coffins.

MICHAEL: Yes, that is sad.

SEBASTIAN: Sad? It's fucking tragic.

MICHAEL: Yes. Tragic. That is what I meant.

SEBASTIAN: Still, like I said. Makes me feel lucky to be drawing breath. The Good Lord up there saw it fit to spare my life.

SEBASTIAN looks heavenward.

(*Shouts.*) Thank you God. Not that I'm any fucking good to anyone.

The two men sit in silence.

What's your name again?

MICHAEL: Michael.

SEBASTIAN: Pleased to meet you, Michael. Put it there brother –

MICHAEL gingerly slaps palms with SEBASTIAN.

The name's Seb.

MICHAEL smiles a greeting. SEBASTIAN gets up and staggers around. He looks at the plants.

Very pretty.

We hear voices. A woman vicar wearing a dog collar, JENNY, and an Asian man, KABIR, enter. KABIR is pushing a wheelbarrow full of fresh rolls of turf.

KABIR: They are having the petition in their hands?

JENNY: Yes. I delivered it myself.

KABIR: They will be seeing sense.

JENNY: Yes, I'm sure they will.

KABIR: It is still being beyond all reasoning. They converted St Mary's into luxury apartments.

JENNY: Can't imagine the yuppies moving in round here. I'm going to speak to the bishop this afternoon. He's on our side. Oh – and don't forget, that journalist's coming in on Friday.

KABIR: Eh?

JENNY: You know, from *The Post*. Said she'd be here for most of the afternoon. (*Preoccupied.*) Hello Michael. Seb.

SEBASTIAN grunts.

MICHAEL: It is a beautiful morning.

KABIR: Hey, Mikey – what's the score?

MICHAEL: Pakistan are still batting. 223 for three wickets.

KABIR: Good. Have you seen Mumtaz this morning?

MICHAEL: No.

JENNY: She's probably hiding in her nest somewhere.

KABIR: She is always coming to greet me in the mornings – quackety – quack – but only silence today.

JENNY: She'll turn up. She usually does.

MICHAEL continues with his work.

Anyway, this journalist's going to be interviewing people – maybe even you.

KABIR: I will be telling her. This place, it is being a community asset – yes?

JENNY: Very good.

KABIR: People are coming here to pray, to mourn, to grieve and to be with their loved ones. I will be introducing her to people to speak with. Mikey?

MICHAEL: Please Kabir – leave me out of it.

JENNY: Your testament would be useful.

KABIR: You must be helping us, Mikey.

A mobile phone rings.

JENNY: This is important. The coverage would be good for us. The more people read about this place, the better our case.

JENNY answers the phone.

Jenny Catchpole? Edith…of course…he's gone into that nursing home…I took him there myself last week. Coming here? Shit.

JENNY moves aside to have a more private conversation.

SEBASTIAN undoes his flies to have a pee. KABIR spots him.

KABIR: Oy, oy, oy…don't you dare be pissing on my plants. And in front of a lady! (*He points at JENNY.*) Shame on you! Put it away.

SEBASTIAN hesitates and then puts it away.

JENNY comes off the phone.

SEBASTIAN: Sorry man. I wasn't thinking.

SEBASTIAN looks a bit shame-faced and staggers off. The others watch him go.

KABIR: Jenny – did you see what he was doing? People are thinking this is being a public toilet! The whole place always smelling of piss.

MICHAEL: (*To JENNY.*) He's a bit of a mess.

JENNY: But the kids love him and his classes at the church hall are very popular.

KABIR: I would not be trusting him with the charge of my children. In his last lesson he was having them all wandering around the graveyard taking photographs of baby graves. Isn't that being a little bit odd?

JENNY: He's an artist. Probably just being creative.

KABIR: Artist – my foot.

JENNY: What's the new turf for?

KABIR: The area by the pond. Especially for your baby photographers and my ducks.

JENNY: Wonderful. I thought that patch was looking a bit rough.

KABIR: Too many people stepping around there. Churning it up into mud – especially you ladies, with your thin pin like heels.

JENNY: Don't blame me. I don't wear shoes like that.

KABIR: And then of course your Sylvester and Sarita – they shit all over it. Huge turds.

KABIR holds out his hands, exaggerating the size.

You wouldn't have thought they would have so much of the crap inside them.

JENNY: I don't know what you've got against those swans.

KABIR: They do not like me. In fact of matter, Sylvester attacked me yesterday.

JENNY: (*Teasing.*) I think you'll find that in a Court of Law, they would define it as self-defence. You were brandishing your spade at him.

KABIR: He was hissing at me, stretching his giraffe neck at me and spitting.

JENNY: You provoked him.

KABIR: Even your swans are racist.

JENNY laughs and then looks at the rolls of turf.

JENNY: I won't ask you how much that turf cost you.

KABIR: It was free… Present from the Parks Department.

JENNY: (*Suspicious.*) Not Bobby?

KABIR: He had some left over, so he is giving it to me.

JENNY looks uneasy.

Don't worry, Jenny. It is all above board, strictly legitimate. Only a few rolls. No one will be missing it.

JENNY looks down at the turf.

Very excellent turf. Good quality. So green. The pond will be looking very beautiful.

JENNY: You mustn't take gifts from Bobby.

KABIR: He is reformed character now. He has stopped drinking, you know and his probation officer even has signed off now. Says he is ready to enter the world as a human being. Bobby is very happy. A new man. Always smiling. See how generous he has been to us.

KABIR points at the turf.

JENNY: Bobby's gifts always come with a price.

KABIR: You are too suspicious. You must do as your God says and learn to forgive, turn the other cheek.

JENNY: Yes, but I only have two cheeks.

KABIR: Then you must keep turning.

KABIR turns his face from side to side. JENNY watches him impassively.

Don't you agree, Mikey?

MICHAEL: No. If you are struck on the cheek once, you must strike back twice.

KABIR: (*Wags his finger at MICHAEL.*) That is not being very Christian of you, Mikey.

MICHAEL: It was a new commandment I invented back home – to stop innocents from being victimised.

KABIR: But we must always be forgiving – no?

MICHAEL: Some things are unforgivable.

KABIR looks at MICHAEL and then at JENNY.

JENNY: It's all relative.

A mobile phone rings. JENNY pulls it out of her pocket and answers it.

Jenny Catchpole? (*She looks at her watch.*) I'll be right there. (*She clicks off her phone.*) I'd better get on. Another bride and groom to talk through the service.

JENNY exits. KABIR gathers his work tools for the day.

KABIR: What are you making today, Mikey?

MICHAEL: A spoon.

KABIR: Another one? How many spoons are you needing?

MICHAEL: This one is for Jenny.

KABIR walks over to MICHAEL and looks at it.

KABIR: To be stirring all her lentil soups?

MICHAEL: She cooked us a very nice meal last week –
not a lentil in sight. Don't be mean Kabir. I don't want
to talk to this journalist.

KABIR: We are needing the publicity for this church. This
is my home, my resting place. I am not wanting to lose it.

MICHAEL: But journalists…they always try and dig up
the past and I find it so – difficult.

KABIR: Don't be talking about the past. Tell them about
how important this place is being to you in the present
and for the future. You are coming here every day – this
is being as much your home as mine.

A school girl, AYESHA, enters. She sits on the bench.

KABIR stops and stares at AYESHA.

You have been cutting your hair short.

AYESHA: Don't you like it?

KABIR: I was preferring your hair long.

AYESHA: I know.

KABIR: A woman's virtue is being in her hair.

*KABIR walks up close and inspects AYESHA's hair. He
looks disappointed.*

Too short. You are not even asking my opinion before
you are having the chop.

AYESHA: It's my hair. I have to look after it.

KABIR: Yes, but I have to be looking at you.

AYESHA: If it's that offensive, don't fucking look then.

KABIR: Hey. Language.

MICHAEL: Morning, Ayesha.

AYESHA: What's up, Mikey?

MICHAEL and AYESHA slap palms.

KABIR sits down next to AYESHA. MICHAEL picks up some rubbish that is littered around. He finds some rubbish by the side of the shed.

KABIR: Why are you being here now? You should be at school.

AYESHA looks down at her flowers.

AYESHA: Come to lay some flowers on Dad's grave.

KABIR: Oh – I'm sorry – I am forgetting. It's today? It's been five years.

AYESHA: Yep. By the way, thanks for tidying up his grave.

KABIR: It was looking a bit tattified.

AYESHA: (*Laughs.*) You mean tatty.

KABIR: How is your mother?

AYESHA: Alright. Bill's still a pig though. Wish she'd chuck the fucker out.

KABIR tuts again. MICHAEL inspects something on the ground near the shed. He looks concerned.

KABIR: You are a nice girl. Why must you be swearing so much? It is very foul to hear such words from your lips.

24

AYESHA: Sorry. But you should see him, Kabir. He sits around in the lounge all evening, hogging the box. Always watching football, we don't get a look in.

KABIR: You must be trying to show your stepfather some respect.

AYESHA: He's not my stepdad. They're not married and with any luck, Mum'll get bored of him, just like all the others.

KABIR: (*Firm.*) You must do well in your exams.

AYESHA: I'm not a brain box.

KABIR: You are a clever girl. You must be making your father proud.

KABIR looks heavenward.

AYESHA: Yeah, yeah.

KABIR: You must be believing in yourself otherwise nothing can be happening. You must be passing these exams.

AYESHA: Fucking hate exams.

KABIR: No, no, that is not being the right attitude. If you are doing well, you will be having a wonderful start in life. Work in an office, wear smart clothes, go out to restaurants for dinner, be having lots of friends and nice holidays…

AYESHA: (*Laughs.*) Me? Work in an office? Fuck off.

KABIR: Ayesha! Stop your foul words.

AYESHA: (*Sighs.*) Sorry.

KABIR gets up and walks back towards his shed. He washes his hands beneath the tap.

KABIR: And study hard.

AYESHA: Alright!

AYESHA picks up her bag and gets up to leave.

MICHAEL: Hey, Kabir, take a look at this…

KABIR: (*To AYESHA.*) And no going chasing after the boys – huh? That can come later.

AYESHA: I'm not chasing anyone.

KABIR: You are a pretty girl. The boys – they will come running.

AYESHA: (*Embarrassed.*) Please… Gotta go.

AYESHA exits.

MICHAEL: Kabir…

KABIR: What?

KABIR walks over to MICHAEL.

MICHAEL: Look, someone has built a bonfire here.

KABIR sifts through the ashes. He pokes around picking up a few feathers. MICHAEL looks anxious.

MICHAEL picks up a feather and shows it to KABIR. KABIR claps his hand to his forehead and looks distraught.

MICHAEL finds more feathers and some bones. He shows them to KABIR.

KABIR: I am recognising these feathers!

MICHAEL: These are Mumtaz's.

KABIR: I am thinking you are right. Someone ate my duck!

MICHAEL: And look…

MICHAEL notices something pinned up on the shed.

Her feet. Chopped off and hung up.

KABIR look sick. He sits on the bench clutching a few feathers, rocking back and forth weeping over the feathers.

KABIR: Mumtaz.

MICHAEL carefully unpins the duck's feet and puts them in his handkerchief.

Ohhh…

MICHAEL: A very sick joke.

KABIR: Whoever it was – He's no better than an animal. It's too upsetting.

MICHAEL: It was probably children, teenagers…they broke in, thought it was a laugh…

KABIR: And her feet…

KABIR holds his head in his hands and looks very upset.

She was my companion. I was nursing her from a duckling when she was having a broken wing. When I was here, she was always waddling around by my side.

Beat as KABIR takes the duck's feet from MICHAEL, unwraps the handkerchief and stares at them.

Her poor little feet.

MICHAEL comforts KABIR.

MICHAEL: I'm sorry my friend.

KABIR is worked up.

KABIR: They are not knowing who they are messing with. I will be catching them. I will be skinning them alive and be roasting them over a fire. See how they are liking it.

MICHAEL continues to comfort KABIR.

Scene 2

It is late afternoon. The sun is low. JENNY leans back in the bench. Her mobile phone is ringing and ringing. She pulls out the phone and switches it off. The sounds of the traffic beyond the wall continue. We hear a banging coming from beyond the wall: a workman sporadically hammering etc. An elderly woman, MARGARET, walks in and approaches JENNY. JENNY virtually ignores her.

The elderly woman stops nearby and looks around.

MARGARET: (*Plummy accent.*) Feel as if I'm in the bloody tropics.

JENNY doesn't react.

A shout goes up from the wall. JENNY and MARGARET look up. KABIR is perched high up on the wall, fixing some barbed wire in place.

JENNY: (*Calls up.*) Kabir – oh do be careful.

KABIR: (*Calls down.*) It's all right – almost finished.

JENNY stands and watches as KABIR is working on the barbed wire. He disappears from view again.

JENNY: What's he doing? He could have hurt himself.

MARGARET: He's a heathen, Jenny. You'd have to convert him. (*Simpers.*) Oh Kabir – do be careful!

JENNY: You have a one track mind. Sad at your age.

JENNY eases off her boots and lays back on the bench. She groans. MARGARET peers down at her feet.

MARGARET: Disgusting.

JENNY: They're killing me. Been throbbing all day.

MARGARET: Unsightly slabs of meat.

JENNY continues to ignore MARGARET and rubs her feet.

MARGARET carefully lifts her dress to show off her feet.

I once had a very dashing beau – before your grandfather. Anyway, this beau once said I had the feet of a goddess. Then he touched his forehead to them and kissed my toes one by one.

MARGARET hands over a letter.

This just arrived by courier.

JENNY takes the letter and looks at it with trepidation. MARGARET peers up at the wall.

Where's Gungha Din got to now?

JENNY: (*Sharp.*) Don't call him that.

MARGARET: And where's his sidekick – Man Friday? This is his spot, isn't it? He's usually ferreting around here. Working on his 'wood'. Whole place is teeming with foreigners and now there's that peculiar Negro hanging around here.

JENNY: Do you ever think before you open that mouth of yours?!

29

MARGARET: Now don't get yourself all worked up…and put your shoes back on darling. You look like a hippy. Aren't you going to open the letter?

JENNY: Later.

MARGARET: Maybe it's from that awful bishop with halitosis? A proposal of marriage!

JENNY: (*Stressed.*) Do shut up.

MARGARET: I had such hopes for you. An Ambassador for the British Government, posted somewhere like Rio or Mexico City…

JENNY: Gran, I'm thirty-four. You can't keep…

MARGARET: I shall go on at you until I die. You've wasted your life marrying yourself to a dying institution. I wanted some great-grandchildren.

JENNY: Go and nag Charlie then.

MARGARET: Your brother's a dead loss. Even I know when to call it a day.

JENNY: At least he's still young.

MARGARET: Yes, but he's probably killed off all his sperm. Drowned them in neat vodka.

JENNY: I'm not interested…

MARGARET: Look at Cherie Blair. She's older than you. God knows how but her husband still finds her attractive enough to give her a good rogering. Have you noticed how the woman's got a mouth like a letterbox? How does the PM kiss her?

JENNY: Gran!

MARGARET: There's still some hope left for you. When you dress up and put on a bit of make up – you're actually almost attractive. You could easily find yourself a husband.

JENNY: I don't want a husband.

MARGARET: There are lots of men your age – second time around – divorced, children living with wife. You'd make a tolerable stepmum – give them moral guidance – that sort of thing. You could even just about have children yourself. But you'd have to get cracking pretty sharpish.

JENNY: I am very happy as I am.

MARGARET: Of course you are dear. Positively brimming over with the joys of life.

SEBASTIAN wanders through. He is carrying a large tripod and camera. He places it carefully to one side. He virtually ignores JENNY and MARGARET.

JENNY: Are you taking some photos here?

SEBASTIAN: Twenty-four hours in the life of the garden. I've got a timer mechanism. It's set to take two pictures an hour.

SEBASTIAN looks around where to aim the camera. He decides to aim it at the bench.

MARGARET: What's this for?

SEBASTIAN: Just a little project for the kids.

JENNY: Very inventive, Seb. Is this your own equipment?

SEBASTIAN: Yup.

KABIR enters. He is carrying some tools.

KABIR: Mrs Catchpole – ah – you are looking ravishing today…

KABIR approaches MARGARET, bends down and kisses her hand. She giggles like a schoolgirl. JENNY glares at her Gran's two-facedness.

JENNY: That was very dangerous what you were doing up there, Kabir. You should have called me or Seb. We could've given you a hand.

KABIR: I was only making a hole in the barbed wire. We were having an intruder last night. Must have been jumping over the wall. He ate Mumtaz.

JENNY: What?

KABIR: Her feathers were being scattered all around shed and they were pinning her feet up on the shed.

JENNY: That's horrible… Who would do such a thing? Depraved…bastards!

MARGARET: It's no surprise though, is it? Probably those ragamuffin kids again – the ones that got in last week…

SEBASTIAN: Don't blame it on the kids.

KABIR watches SEBASTIAN suspiciously. JENNY looks upset.

JENNY: Poor Mumtaz.

KABIR: Sebastian – what are you doing?

SEBASTIAN: Twenty-four hours in the life of the garden.

KABIR: It will be getting nicked.

SEBASTIAN: I'll check it regularly.

KABIR: It will be getting in my way.

SEBASTIAN: It's only for twenty-four hours.

JENNY: Hold on, if they came over the barbed wire – why are you making the hole bigger?

KABIR: Tempting the thieving vandals in. Tonight, I will be staying here and keeping watch for them.

JENNY: You should be careful.

KABIR: We must be protecting these grounds. People are depending on us.

JENNY: I don't want you taking the law into your own hands. We're in enough trouble as it is.

KABIR: Aren't you caring about this place?

JENNY: Of course I do. It's you I'm worried about. You're not a security guard.

KABIR: They killed my duck! And I will defend this place to the end.

JENNY looks at KABIR with admiration.

Anyway, we must be keeping these grounds looking good for the journalist. Making a good impression.

JENNY: Exactly. I'll join you tonight. A midnight vigil – might be quite exciting.

MARGARET: You can't. We've got dinner at the Hendersons.

JENNY: Shit.

KABIR: I will be fine. Always we have such problems with criminals and trespassers.

MARGARET: It's a wicked world.

KABIR: When first I started my work here, it was being the Gulf War. Someone was scrawling all over the wall there – 'Bomb Iqaq'.

MARGARET: Iqaq?

JENNY: They couldn't spell.

MARGARET: The English language – murdered by illiterates and foreigners.

JENNY: Gran!

KABIR: Margaret, you are being a very naughty lady. Too many years you have been spending as a diplomatic's wife.

MARGARET: Diplomat. Anyway, Gus was a military doctor. There is a difference.

KABIR: It is still being the same, same. Looking down your nostrils at everyone. Being of a patronising nature is in your blood. You are being taught from early age to be superior – no?

JENNY: Too right.

MARGARET: Here I sit accused and guilty.

JENNY: Gran – it's nothing to be proud of.

KABIR: And it is in your religion.

JENNY has heard all of this before. She looks at her watch.

You people stampeding all over the world, killing. Bible in one hand and sword in the other. No? The foundations of your religion are being based on the

blood of conquered religions, countries converted to Christianity. Missionaries in Africa, church building all over the world…

MARGARET: Hey listen, darling, I'm no Christian. I'm simply a bigot.

KABIR: At least you are being honest, Mrs Catchpole.

JENNY: Don't encourage her.

KABIR: 'And ye shall make no league
with the inhabitants of this land;
ye shall throw down their altars…
They shall be as thorns in your sides,
and their gods shall be a snare unto you.'

Judges.

JENNY laughs and applauds KABIR. He takes a bow.

JENNY: You're so good at taking things completely out of context.

SEBASTIAN smiles to himself. He checks that the camera is working by taking a few photographs.

You forget the Bible talks to us about tolerance and the humanity of all living beings, love thy neighbour, peace and understanding and…

KABIR: Jesus was taking those ideas from India. Very famous ancient texts written in Sanskrit.

JENNY: You really shouldn't believe everything you read in the papers.

KABIR: Hard evidence, Jenny.

JENNY: Still haven't convinced me though.

KABIR: They talk about how a young boy from Nazareth visited the old sages in the foothills of the Himalayas. He called himself Jesus and he was staying in India between the ages of thirteen and thirty.

MARGARET: That explains what he got up to.

KABIR: He was learning yoga and the arts of herbal medicines, meditation, rising above oneself. He was finding out about the concepts of 'love thy neighbour, turn the other cheek, peace and tolerance' and all those things you are claiming to be yours.

JENNY: Ever heard of the universality of all faiths?

KABIR: Universality is being a wishy-washy description. Very convenient.

JENNY: Like your story.

KABIR: It is not a story. It is being a fact. Jesus was nicking all his ideas from the Hindus. He got it a bit wrong when it was coming to being the Messiah. The Hindus are saying we are all the sons of God – Jesus was taking it too literally and claimed *he* was *the* son of God. Then he was travelling back to his homeland to be spreading the word about his new faith – the Romans were getting annoyed with him and were crucifying him but he was not dying because of the yoga he was learning, he rose above his pain and fell into a spiritual trance.

MARGARET: Then what happened?

KABIR: He woke up, in a tomb, got up and Mary Magdalen thought he was the gardener.

JENNY: (*Laughs.*) A gardener!

KABIR: It was giving him an idea and so he was going back to India where he was working for the rest of his life with plants. He was dying when he was about sixty-five. Some have said they are knowing where his grave is.

MARGARET: (*Fascinated.*) Where?

JENNY: In Kabir's home town, of course.

KABIR: Well – yes. In Kashmir.

JENNY: In the foothills of the Himalayas where he'd be closer to God.

KABIR: He is being buried as a Jew because the Hindus are a very exclusive club. You cannot be converting to Hinduism.

JENNY cracks up laughing.

It is true!

MARGARET: So, walking on water was nothing next to walking on hot coals.

KABIR: He was learning it from all those mad Hindu sages.

KABIR gives JENNY a meaningful look and then wanders off.

SEBASTIAN stands back.

SEBASTIAN: All set.

He exits.

MARGARET: Not very communicative, is he?

JENNY: Unlike some people round here, he thinks before he speaks.

JENNY opens the letter and reads it quickly. MARGARET watches as JENNY looks crestfallen.

MARGARET: Bad news I take it?

JENNY: I can't believe it.

MARGARET: What?

JENNY: This can't be right.

JENNY re-reads the letter.

MARGARET: What?

JENNY: They turned down our appeal.

MARGARET: I'm sorry, dear. Perhaps the petition might make a difference.

JENNY: Too late now. How am I going to tell Kabir?

JENNY looks distraught.

MARGARET: It's time you came clean. You haven't exactly been totally honest with him have you?

JENNY: Meaning?

MARGARET: Meaning, you knew this was likely to happen.

JENNY: I was hoping… I thought there might be an outside chance…

MARGARET: It's never wise to give a man false hope.

Scene 3

It is night time. KABIR is arranging some lanterns around the bench for his midnight vigil. Once they have been set up, he gathers

a shawl around his head and body, picks up his machete and sits on the bench and waits. He looks up at the tree and the wall from time to time. All he can hear is the sound of traffic and the flash of headlights.

We hear the sound of a woman's weeping, soft but anguished, coming from the shed. The woman's voice calls out his name in anguish.

WOMAN: (*Voice off.*) Kabir! Kabir!

> *KABIR does not flinch. Instead, he turns SEBASTIAN's tripod and camera around so it is facing the tree.*

> *He hears the sound of a car approaching, car door slamming and footsteps. KABIR raises his machete.*

MICHAEL: (*Off.*) Kabir?

KABIR: (*Calls back.*) Ah! Mikey.

> *KABIR throws down his machete and goes off stage. We hear the gate being unlocked. MICHAEL and KABIR enter. MICHAEL is carrying some books under his arm.*

> What are you doing here so late?

MICHAEL: I could ask the same of you my friend.

> *KABIR ushers MICHAEL to the bench.*

KABIR: I am glad you are coming. Sit, sit.

> *KABIR looks around surreptitiously as if afraid he will be overheard.*

> I am doing stake out.

MICHAEL: For what?

KABIR: I am waiting for the criminal who has defiled the grave yard. Would you like some masala chai?

MICHAEL: Oh yes please…

KABIR: Good.

KABIR scurries off to his shed and disappears for a second.

He re-emerges a few seconds later carrying a thermos flask and two mugs. He gets busy pouring the tea. Then he pours a generous amount of whiskey into it.

MICHAEL: Thank you. So you think the intruder will return?

KABIR: He will come back. I just hope the end for Mumtaz was quick and that she did not suffer.

MICHAEL looks at all the lanterns KABIR has set up.

These are bad times.

MICHAEL: (*Puts his hands together in prayer.*) The Lord almighty, grant us a quiet night and a perfect end. Be sober, be watchful. Your adversary the Devil prowls around like a roaring lion, seeking to devour. Resist him, firm in Your faith. Amen.

KABIR produces a packet of cards from his pocket and automatically starts to deal. MICHAEL picks up his cards. This is obviously a ritual they have. They start to play. MICHAEL jumps as SEBASTIAN's camera flashes. He looks up at the camera – frightened.

KABIR: Don't worry – Sebastian's camera – he is doing some project – rubbish. I turned the camera away. He will be getting some very nice photos of the tree.

MICHAEL: Hey, Kabir… (*He giggles.*) Do you think he really was a photo-journalist? His hands are so shaky – how does he hold the camera still?

KABIR: He is being a liar. You ever been seeing any of his photos? All talking, talking and no evidence.

MICHAEL and KABIR share the joke.

MICHAEL: Jenny told me he used to be a famous photographer – traveled the world – apparently.

KABIR: Jenny will be believing any story she is hearing. Too trusting. They come here, they are pulling her strings, she is feeling sorry for them…

There is a rustle of leaves and the sound of someone approaching. They both freeze. KABIR gets up slowly and as the figure enters he ambushes the intruder, there is a struggle as KABIR wrestles him to the ground. MICHAEL stands by, worried.

(*Shouting.*) Think you can be coming in here killing my duck…? Eh?

MICHAEL: Kabir – be careful…don't hurt him.

SEBASTIAN: Help! Help!

MICHAEL shines a torch on the intruder's face.

KABIR: SEBASTIAN!

KABIR looks annoyed. MICHAEL helps SEBASTIAN to his feet and then brushes him down.

SEBASTIAN: That's quite a welcome.

MICHAEL: Are you okay?

SEBASTIAN looks a bit winded but nods. We see he is carrying a camera. He checks it to make sure it's okay.

KABIR: (*Ungracious.*) Sorry – I thought you were being an intruder.

SEBASTIAN: The gate was unlocked.

KABIR: Why are you being here anyway? The graveyard is closed now.

SEBASTIAN: This a private party?

KABIR: Yes.

MICHAEL: No. Please, sit down.

SEBASTIAN plonks himself down on the bench next to them.

KABIR looks accusingly at MICHAEL.

SEBASTIAN: Hey, you got any booze stashed in that shed of yours?

KABIR: No.

SEBASTIAN eyes KABIR and MICHAEL'S drinks.

MICHAEL: It is masala chai – Kabir's special concoction. Want some?

SEBASTIAN: Yeah – since you're offering.

KABIR pours a drink from his flask and hands it over ungraciously to SEBASTIAN. He takes a sip. MICHAEL watches carefully for a reaction.

Not bad.

MICHAEL is pleased. Another sip

Very nice in fact.

MICHAEL slaps SEBASTIAN affectionately on the back.

Taste even better if it was spiked. Still. Cheers.

SEBASTIAN gets up and looks at his camera.

Who shifted this?

KABIR and MICHAEL are silent. SEBASTIAN rearranges the camera so that it is pointing the right way.

MICHAEL: How are your classes going?

SEBASTIAN: Okay. They're good kids.

KABIR: They are ruffians. Always leaving the hall in a terrible mess.

SEBASTIAN: They're just young. Not properly house-trained.

MICHAEL: Jenny says you are a good teacher.

SEBASTIAN: (*Pleased.*) Does she?

MICHAEL: Yes. I saw the little photograph exhibition in the church hall last week. It was good.

SEBASTIAN: (*Delighted.*) Thank you. We worked hard on that.

SEBASTIAN spies a plant.

Red chillies and what's this?

KABIR: Coriander and over there methi. It is reminding me of home. Ten years since I was being there.

MICHAEL: Are you missing Nadia?

KABIR: You are knowing how it is, Mikey.

MICHAEL: Of course.

SEBASTIAN: Who's Nadia?

KABIR: My daughter.

SEBASTIAN: You got a daughter?

KABIR: Back in India.

SEBASTIAN: She ever visit you here?

KABIR: I have deliberately kept away from her. She doesn't know even that I am alive.

SEBASTIAN: Absentee father.

KABIR: She is safe, she is nearly sixteen, she will marry one day – I am sending my brother money regularly.

MICHAEL: You should write to her. It would give her hope.

KABIR: What good would it be doing?

SEBASTIAN: That's fucking heavy shit – that is. You got a kid who doesn't even know you're alive?

KABIR: I have nothing to be offering her.

SEBASTIAN: My kids don't want to know me. Think I'm a loser. Slam the phone down on me…call me an animal. They want to come and see the world through my eyes…but they don't care…don't want to even know. I need a drink.

MICHAEL produces his books.

MICHAEL: (*To KABIR.*) I got these for you – from the library.

KABIR: Books? For me?

MICHAEL: Mainly photographs.

KABIR looks excited as he takes the first book and crouches by the lantern to flick through it. SEBASTIAN gets up and takes a look over KABIR's shoulder.

KABIR: A shikara! (*He laughs.*) And the houseboats. My grandfather worked as a cook on one of those boats.

SEBASTIAN: Beautiful.

KABIR: This is wonderful. Thank you, Mikey.

MICHAEL: I saw them and I thought my old friend would like to see his birthplace.

KABIR continues to flick through the book excitedly.

SEBASTIAN: The light's amazing. Looks like paradise.

KABIR: That is why everyone is fighting over it.

KABIR looks at MICHAEL and SEBASTIAN full of hope.

Sometimes I am dreaming of returning to my village in a shikara, covered in lotus blossoms. In a jewelled trunk, I have beautiful expensive embroidered shawls and silken garments for my family. I see them all standing there waiting for me, cheering.

MICHAEL: It could happen.

As KABIR speaks we see the shadow of a woman's figure, standing in the doorway of the shed.

KABIR: I am walking through the village and everyone is there – my Nadia – a little girl again – my older brother – (*Laughs.*) he is still scolding me for leaving them for such a long time. I have been away ten years but they are all the same, they have not aged. My mother rushes up to me and kisses my face and my uncle is eyeing the jewelled trunk greedily. And there,
I can see her outline, my wife – Nusrat – she is standing, half hidden in the shadow of our doorway, anxious. Have I changed? Has England made me different?

45

*KABIR stretches out his arms longingly. MICHAEL and
SEBASTIAN watch. The woman's shadow disappears.*

I want to stroke her face but I am not being able to see
her. Her veil is drawn around her head – or is it the
shadow of the door?

MICHAEL: It is a nice dream to have but we cannot turn
the clocks back, my friend.

KABIR is silent. SEBASTIAN looks baffled.

SEBASTIAN: You…lost your wife?

KABIR: She was taken from me.

SEBASTIAN: Sorry man.

KABIR tries to cheer himself up.

KABIR: But, no more looking backwards. I am having
plans. I am wanting to start a new family.

MICHAEL: (*Surprised.*) Are you?

KABIR: Oh yes.

SEBASTIAN: Who's the lucky lady?

KABIR touches his nose.

KABIR: Everything will be revealed in the ripeness of
time.

SEBASTIAN turns to MICHAEL.

SEBASTIAN: Where are you from then?

MICHAEL: Africa.

SEBASTIAN: Is a continent. You can't be more specific?

MICHAEL: Rwanda. You heard of it?

SEBASTIAN: Yeah – I've heard of it.

MICHAEL: That's my country.

SEBASTIAN: I'm sorry.

KABIR: Mikey here was a man of the cloth.

MICHAEL: A travelling pastor. Now I have no church and no country.

SEBASTIAN: What about this church?

MICHAEL: I cannot pray here.

He taps his forehead.

SEBASTIAN: Don't you think you'll ever go back home?

MICHAEL: No.

SEBASTIAN: Really?

MICHAEL: I cannot forget what I saw. And my little boy…

MICHAEL is emotional and upset. KABIR pats his friend's hand affectionately.

KABIR: Losing a child – I cannot be imagining how terrible that must be.

MICHAEL: Because of me. I should have saved him. I should have died there with my family.

KABIR: Life is indeed being a mystery. But you must live and be counting your blessings. You are surviving for a reason. And his remains are being at peace here.

SEBASTIAN: You buried him here?

MICHAEL: No – just some of his things. I could not give him a proper grave – so I…

KABIR: We were doing it together – a few of his personal effects in a small box.

The three men sit in silence.

(*Looks up at the wall.*) No sign of the bastard duck murderer.

MICHAEL: I don't think he will be coming.

KABIR: Why?

MICHAEL: I dropped in because I saw the light from your lamps.

KABIR: (*Irritated.*) Oh. You see? Another example of my excellent stupidity. Sit and wait for the intruder with all the lights on. Surely, I am being the biggest genius you have been meeting for a long time?

MICHAEL and KABIR laugh.

MICHAEL: I think you are a genius.

They laugh more.

KABIR: Detective Inspector Kabir.

MICHAEL: DIK for short.

They both crease up. SEBASTIAN joins them in their laughter.

I saw your lights and I thought to myself, 'That Kabir is having a party.'

KABIR: Yes, yes, party in the graveyard with all my friends the five thousand dead. So you were thinking – 'I must be joining him.'

MICHAEL: It was just an excuse for you not to go home, eh?

KABIR: It is a warm night.

MICHAEL: It is not a place I would like to be in after midnight…

KABIR: Are you scared of the dead?

MICHAEL: No.

SEBASTIAN: I am.

KABIR: They are gone – rotting flesh and bones turned back to the earth. The graves are for the living to visit. That is all.

SEBASTIAN: Hope you're right.

KABIR: Yes. Although, once I saw Satan –

MICHAEL: You saw the Devil? Here?

KABIR: I only was seeing him the one time many years ago. And he was gone very quickly.

SEBASTIAN: You wind-up merchant.

MICHAEL: What did he say?

KABIR: He didn't speak.

SEBASTIAN: Did you tell Jenny? She wouldn't be very happy if she knew the Devil was lurking around her backyard.

SEBASTIAN puts on a rasping scary voice.

I am the evil one. Come join me in a diabolical union and together we will lead the world into corruption and devastation.

KABIR: You are taking the piss from me.

MICHAEL: I believe you!

SEBASTIAN: Come off it.

KABIR: I am telling you, he was there. I saw him sitting
on Alan Harwood's grave. But before I was seeing him,
I was having the smell of lots of burning matches.
I looked around and he was just…there…smiling at me.

*KABIR points to a nearby grave. MICHAEL and
SEBASTIAN look at it in fear.*

His legs were swinging and he had a huge cloak – it
wasn't exactly flapping in the wind – it was doing this
magic floating around him, like waves. It made my
stomach feel dizzy.

SEBASTIAN: It'd scare the shit out of me.

MICHAEL: I would be terrified.

KABIR: I was at the time. Very tremendous pounding in
my heart. He has…this…most beautiful smile – like he
is so delighted to be seeing you. An old friend he loves
dearly. And you are feeling his compassion reaching out
in that smile through the breath in his mouth. And you
know, he can be drawing you in with just a small intake
of his breath.

MICHAEL crosses himself.

Satan's smile – most alluring and sweet. My father was
once telling me that if you see the Devil smile at you –
you must be very careful.

MICHAEL: Why?

KABIR: He is wanting you as his disciple. He has been
picking you out as a special candidate for his affections.

MICHAEL: And you say he never spoke to you?

KABIR: No. But I was knowing he was waiting for me. And then he was gone. Not vanished in a puff of clouds but just gone.

MICHAEL: What did you do then?

KABIR: I called to Allah for mercy and I cried.

KABIR falls to his knees and raises his hands in prayer.

We praise Allah. Peace and blessing be upon him. We bear witness that there is no God but Him. Grant to me the love of You; grant that I may do the deeds that win Your love; make Your love dearer to me than self, family or wealth.

SEBASTIAN: Did he ever come back?

KABIR: No. But sometimes I can feel him. There are certain people who he is attracted to – like a fly is to shit. I thought he was close by today – patiently marking time – on the look-out.

MICHAEL: For you?

KABIR: Oh yes.

SEBASTIAN: You were smoking some wicked shit that evening? Eh? I'm right, aren't I? A little trippy skunk maybe?

MICHAEL: He probably grows it himself.

KABIR: I am telling the truth.

MICHAEL and SEBASTIAN giggle together.

SEBASTIAN: What would Satan want with a gardener anyway?

KABIR: I have committed my sins. I have to be answering for myself.

MICHAEL: Don't talk rubbish, Kabir.

KABIR: It is true. Why do think I am here? Because I am in hiding and the only person until now who is knowing my business is the Devil. You cannot be hiding from Satan.

SEBASTIAN: What did you do?

KABIR: That is between me and the Devil. But one day, he will be catching up with me – no matter how far I am trying to run.

SEBASTIAN and MICHAEL stare at KABIR in amazed silence.

MICHAEL: If you want to really do a stake out, you need to be alert. Keep a watch out, quieten down and lay a trap for him.

KABIR: Ah yes…you are giving good advice.

MICHAEL gets up and switches all the lamps off. The three sit in the dark.

MICHAEL: There is an art to capturing and cornering your enemy. You must use the cloak of the night to cover you and work on their fear.

KABIR: But I am not seeing anything.

SEBASTIAN: Hey – switch the lights back on. It's freaking me out.

MICHAEL: Shhhh… Wait, your eyes will accustom themselves.

KABIR: I can see you now.

MICHAEL: You must keep your ears pinned back.

KABIR: I...

MICHAEL: Shhh...wait...

The three are silent for some moments. Then suddenly MICHAEL switches on a lamp and points it straight at KABIR's face. He screams at the top of his voice.

Whatareyoudoinghereyoumotherfucker? I'm going to chop you to pieces and leave you to rot with the dead!

MICHAEL grabs KABIR by the scruff of the neck and shakes him hard. At this point, the camera suddenly flashes, taking a picture of MICHAEL. MICHAEL stops abruptly and switches on the lights. KABIR is in a state.

I am sorry...oh my God are you okay?...I was just playing around...trying to show you...

KABIR takes some time to get his breath back. MICHAEL helps him up and looks suspiciously over at SEBASTIAN.

KABIR: Where did you learn to do be doing that?

MICHAEL: I am sorry.

KABIR: No, that was being fantastic!

SEBASTIAN: Good party trick man. You convinced me.

MICHAEL continues to look at the camera and SEBASTIAN uneasily.

Scene 4

It is early morning. MARGARET enters, looking for KABIR.

MARGARET: Yoo, hooo… Kabir…Kabir?

As she goes around the back of the garden, a big figure looms up behind her. MARGARET screams to high heaven.

SEBASTIAN: Hey, hey, lady…please…it's me…don't panic.

MARGARET stops screaming and looks closely at SEBASTIAN.

SEBASTIAN: Sorry.

MARGARET: What are you doing here?

SEBASTIAN nurses his head.

SEBASTIAN: Don't shout, lady.

MARGARET: …Well really…you could have given me a heart attack. Do you know how old I am? Were you sleeping here?

SEBASTIAN: Must've crashed out.

MARGARET: More like collapsed. Young man, this isn't a doss house you know.

SEBASTIAN continues to nurse his head.

You should straighten yourself up and buy yourself a decent shirt.

SEBASTIAN sits down and rolls himself a cigarette.

You remind me of a houseboy we used to have in our place in Kenya. Jonathan.

SEBASTIAN: Do I?

MARGARET: Very surly, terrible manners but as bright as a button. I heard he went on to become an office clerk – probably running the country by now.

SEBASTIAN remains quiet.

Where are your parents from?

SEBASTIAN: Trinidad. Been there?

MARGARET: Oh yes. Beautiful.

SEBASTIAN: Too many black people though – eh?

MARGARET: I never understood why it's so difficult to have a simple conversation with you people. You always take offence and turn aggressive.

SEBASTIAN: It's too early in the morning for this.

SEBASTIAN staggers over to the tap and scrubs his face with water.

MARGARET: Have you got a woman?

SEBASTIAN: You offering?

MARGARET: (*Giggling.*) If you cleaned your act up – perhaps I might consider it.

SEBASTIAN: Ever slept with a black man?

MARGARET: Yes, Jonathan. Gus – my husband probably knew about it but he didn't care. Too busy screwing every local coloured woman he could get his paws on. God knows how many poor women he impregnated. Jenny tells me you used to be a famous photographer.

SEBASTIAN: A long time ago. Anywhere there was a story, I was there. Bhopal, Cambodia, Nicaragua…

MARGARET: The evil drink – eh?

SEBASTIAN: Got sick of hiding behind the camera lens. Still life misery.

AYESHA enters. She is carrying a tatty folder under her arm. She hesitates when she sees MARGARET.

MARGARET: Hello Ayesha.

AYESHA: (*Wary.*) Hi. (*To SEBASTIAN.*) What's up, Seb.

They slap palms. AYESHA sits on the bench. She looks upset. MARGARET spots the banana tree.

MARGARET: Good God, he's actually installed a banana tree here. Where is Gungha Din anyway?

AYESHA: Kabir?

MARGARET: I need to talk to him.

AYESHA: Apparently he's terracing the slope next to the pond.

MARGARET: Terracing? What's he going to do now? Irrigate the graveyard and stick some paddy fields there?

AYESHA: No, it's for the fountain he's planning to have installed later.

MARGARET: Fountain.

AYESHA: Yeah – he's cutting into the slope to make a terrace and then he's going to put a fountain at the top of the slope. Last of all he'll make a little pathway for

the water to flow down through the terraces and into the pond.

MARGARET: That'll confuse the ducks.

AYESHA: He thinks if he makes everything beautiful, the Church Council will change their minds.

MARGARET: So he still doesn't know.

AYESHA: Know what?

SEBASTIAN: (*To AYESHA.*) Do you know where Michael buried his son's things?

AYESHA: Eh?

SEBASTIAN: He's buried something here – is it in the grave yard or here in the garden?

AYESHA: I don't know.

SEBASTIAN looks disappointed. He exits.

He's mental.

MARGARET: Should be certified if you ask me. I've been meaning to ask you, Ayesha, where exactly are you from?

AYESHA: Just down the road – Stanley Road. You know it?

MARGARET: No, I mean originally?

AYESHA: I was born in Battersea.

MARGARET: (*Seeing as she's getting nowhere.*) And before that?

AYESHA: Before my birth?

MARGARET: Your parents dear – where are they from?

AYESHA: Dad was English and Mum's from Turkey – a little town outside Istanbul. Actually, Dad wasn't really English. His dad was Scottish – that's my grandfather and my grandmother's half Irish and a quarter Norwegian and a quarter something else…

MARGARET: Quite a mix and match in your family then.

AYESHA: Yeah, s'ppose.

MARGARET: So – what are your life plans?

AYESHA: Eh?

MARGARET: Surely, you must know what you want to do in the future?

AYESHA: I'd like to travel. I'm going to be an air hostess.

MARGARET: But they're just glorified waiters.

AYESHA: Get to travel the world though. I could see me some volcanoes, a few mountain ranges – stand on top of the world… Got to hang out in Turkey for a bit – then make my way to India and the Taj Mahal…monument to love and all that stuff.

MARGARET: Don't you want to go somewhere civilized like the States or Australia, New Zealand – what about Europe?

AYESHA: Seen it all on telly. Not much different from here, is it? Apart from the open spaces. And the Americans are mad, aren't they? They carry guns and kids shoot each other in the playground. No thanks.

MARGARET: So you're after adventure of the soul.

AYESHA: Yeah.

MARGARET: (*To AYESHA*.) You ever been to Turkey?

AYESHA: A few times. Got lots of cousins and aunts out there. I'd like to go and live there one day.

MARGARET: (*Astonished.*) Would you?

AYESHA: Yeah – why?

MARGARET: Well, it's just that you seem so westernised. I mean, they'd cover you up from head to toe and you'd never be able to earn a living – always have to walk three steps behind your husband and when he tired of you he can just say 'talak, talak, talak…' and you're divorced.

AYESHA: It's not as bad as that…

MARAGARET: Terrible reputation the Turks have – my husband was posted to Istanbul for a couple of years. I, of course, was there with him. Human rights violations, not to mention what they've done to the Kurds. Mind you they were always trouble makers.

AYESHA: Who?

MARGARET: The Kurds. Nomadic farmers and goatherds. Always too proud and too nationalistic for their own good. You seen my granddaughter?

AYESHA: Erm…no.

MARAGRET: Discovered God after a terrible shock – love on the rebound – fiancée jilted her at the altar and ran away with her best friend.

AYESHA: Oh…

MARGARET: Tell me – d'you think there's something going on between Jen and the gardener? You know – any hanky panky.

AYESHA: 'Course not!

MARGARET: You *are* young, aren't you, dear?

AYESHA: You got a life plan?

MARGARET: My life plan never changed. Don't want to die on my own – have them find my body rotting, full of maggots three weeks later.

Beat.

AYESHA: How old are you?

MARGARET: You should never ask a lady's age. Very bad manners.

AYESHA rolls up her shirt, baring her midriff and tucks up her skirt into her knickers baring her legs. She lays down on the bench and places her file over her face to shade the sun.

I'll let you get on then.

MARGARET exits. KABIR enters pushing a wheelbarrow. He spots AYESHA and shakes his head and tuts.

KABIR: You should be studying. Not lying around half naked.

AYESHA hurriedly gets to her feet, making herself more presentable.

AYESHA: Can't revise at home…and the sun's so warm and relaxing… Margaret was looking for you. Weird old bird, isn't she? D'you think she's alright upstairs?

KABIR: What is being the matter?

AYESHA: Nothing.

KABIR: Don't be doing that 'nothing' business with me young lady.

AYESHA: What?

KABIR: I am knowing you too long. You are looking like a lost puppy.

AYESHA: Don't talk bollocks.

KABIR: Something is happening at home?

AYESHA is quiet.

I know something is being wrong. You are coming to talk to me specifically. It is being the morning. You should be at school.

AYESHA: I've got a free period.

KABIR: You would rather be here than twittering with your girlie gang? Tell me. He has been beating you?

AYESHA: No!

KABIR: What then?

AYESHA: Nothing.

KABIR sits down next to AYESHA. He pulls her head affectionately onto his shoulder. She leans there for a moment.

I hate him.

Beat.

He did something awful.

KABIR: What?

AYESHA: He chopped the tree down.

KABIR: Your dad's magnolia tree?

AYESHA: I come back from school and the fucker had got these tree surgeons round. They chopped it down. He said it was blocking out the sun. Never even asked me.

KABIR: *Ban Chod.*

AYESHA: I remember Dad planting it.

KABIR pats AYESHA's hand affectionately. But we can see he is furious.

KABIR: Anyone who can be taking a life from a tree is not to be trusted.

AYESHA: He knew it was my dad's tree. That's why he did it.

KABIR: How can your mother be letting this happen?

AYESHA: She was upset. But she won't say anything to him.

KABIR: He is being a very bad man.

AYESHA: He's a shit. I need to get through these exams and then I can go.

KABIR: Where?

AYESHA: Away, anywhere.

KABIR: You are still being a baby.

AYESHA: I'm nearly sixteen.

KABIR: Are you believing in fate, Ayesha?

AYESHA: Fate.

KABIR: You are in my garden for a reason.

AYESHA looks uneasy.

I am remembering the day you were burying your father. You, a little girl – only ten. It was breaking my heart seeing you.

AYESHA: I loved my dad.

KABIR: I know. And that is why, I think you and I have become so close.

AYESHA: We're mates.

KABIR: I have been coming to a decision.

Beat.

I will adopt you.

AYESHA: What?

KABIR: We will be going to the authorities together and be making it official.

AYESHA: Erm…

KABIR: We will be taking out an injunction against this Bill. Jenny will be helping us.

AYESHA tries to take this information in.

I have been thinking about it for some time. Now is the time for being active.

AYESHA: You're so weird.

KABIR: I want to be helping you. You are being on the brink of your life, you are needing the protection of a father. I can be that father.

AYESHA: No offence, Kabir, but… You're serious, aren't you?

KABIR: My bedsit is being too small, so we will have to be looking for a bigger house.

AYESHA: Kabir…

KABIR: Maybe the authorities will be helping us.

AYESHA: I can look after myself.

KABIR: I will be guarding you from the world.

AYESHA: I don't want a fucking guard.

KABIR: Language, Ayesha.

AYESHA: …it's very sweet of you but the last thing I want right now is to tie myself down with yet another family. And anyway, how d'you think the authorities will look at us – eh?

KABIR: What are you meaning?

AYESHA: You're a single bloke.

KABIR doesn't get it.

KABIR: So?

AYESHA: It doesn't look good does it? And I ain't gonna shop my mum to the SS. She'll get it in the neck.

KABIR: She is not being capable of looking after you as a mother should be caring for her child.

AYESHA: (*Angry now.*) She's still my mum.

KABIR: I can be looking after you. Please Ayesha…

AYESHA: No – man.

KABIR: I can be your father.

AYESHA: No. Thanks for the offer but – no.

KABIR: I am offering you a chance to be changing your life, not to be living in fear.

AYESHA: Do I look like I'm living in fear? I'm angry, not scared.

KABIR: You should be taking the offer with gladness.

AYESHA: I don't need your charity.

KABIR: For five years I have been watching you grow and all the time, your mother has different boyfriends – it is not being good. It is not being right.

AYESHA: What the fuck do you know about my mum?

KABIR: What you are telling me.

AYESHA: You don't know her though.

KABIR: You are needing better guidance, a shoulder to be leaning on, someone who is listening to you. I am standing here, wanting to take the responsibility.

AYESHA: I'm not some little fucking stray.

KABIR: Please. Give me the chance to be proving what a good father I could be.

AYESHA: No. NO.

She exits. KABIR looks upset and confused. He sits down on the bench for a few moments and tries to gather himself. SEBASTIAN enters. KABIR ignores him.

SEBASTIAN: We need to talk.

KABIR: What would I be wanting to be talking to you about?

SEBASTIAN: It's about Michael… What's he got buried here?

KABIR: How is that being your business?

SEBASTIAN: D'you know where it is?

KABIR: Why should I be telling you?

SEBASTIAN: Just do me a favour – eh? Tell me where that thing's buried and I'll dig it up.

KABIR: You are being ridiculous.

SEBASTIAN: Tell me!

KABIR: Are you being drunk again?

SEBASTIAN: Did you see what was in the box? Did you see the contents with your own eyes?

KABIR: No…but I am not needing to. They were his sons' belongings.

SEBASTIAN: Are you sure?

KABIR holds his hands up as if in surrender.

KABIR: You are being very mad, Sebastian.

SEBASTIAN: Listen to me, man!

KABIR gets up and gets back to work.

KABIR: My head is being full. I cannot be listening to your ravings.

SEBASTIAN: Michael's a bad man. You gotta help me – I need to find that box.

KABIR: You are being a complete mess. You are being drunk all of the time – look at you! Crazy idiot.

SEBASTIAN: I'm not crazy – I can explain…

JENNY enters. She is talking on her mobile phone.

JENNY: I thought that perhaps maybe I could come and see you this evening? I see…

SEBASTIAN falls silent. KABIR tends to his plants – clipping, watering, etc. JENNY looks at him anxiously.

Okay. Fine. Thanks…for listening. I'd better go. Bye.

JENNY clicks off her phone. SEBASTIAN goes off to one side and starts dismantling his tripod and camera.

KABIR: Hot line to God? Or was it Jesus Christ?

JENNY ignores him and paces. KABIR watches her.

You are making me nervous.

JENNY: What?

KABIR: All this marching up and down…

JENNY: Sorry.

She sits on the bench and watches KABIR. She fiddles and can't sit still.

Kabir. This church and the graveyard…

KABIR: We should be hearing about the appeal any day now – yes?

JENNY: Yes… You've put a lot of work into this place.

KABIR: So have you.

JENNY: Kabir, there's something I need to tell you…

MARGARET enters with MICHAEL.

JENNY looks annoyed. She's missed her chance.

MICHAEL: They bury the bananas in the ground to help them ferment. Only takes a few days because of the heat.

67

MARGARET: That's how they make banana beer?

MICHAEL: Of course, that was the first hint they had in Goma that the volcano was about to erupt because the bananas only took one day to ferment. The ground below was bubbling.

MARGARET: Fascinating.

MARGARET spots KABIR.

Ah there you are…

She looks carefully at JENNY and KABIR.

MICHAEL sits down on the bench. He is clutching a Bible. SEBASTIAN is still fiddling with his camera.

KABIR: You were looking for me?

MARGARET looks around the garden with approval.

MARGARET: Such a peaceful corner of the graveyard. It really is looking quite lovely.

KABIR: Ah…but I have bigger plans. You know that little patch of green in the west part of the graveyard. I am thinking of making a little pergola there, with a small gathering of trees. Then people can be sitting and resting there. I will not be starting work until we are knowing for sure but…

MARGARET: Kabir – I thought we were being booted out.

JENNY: (*Warning.*) Gran…

KABIR: We are still waiting for the conclusion of the appeal.

MARGARET: You mean Jen hasn't told you yet?

JENNY: No – I haven't, Gran.

KABIR: Told me what?

MARGARET: You didn't know?

KABIR: Didn't know what?

JENNY: Gran. I specifically said…

MARGARET: I'm sorry…I thought you knew…me and my big mouth.

KABIR: What are you talking about, Mrs Catchpole?

MARGARET: It's nothing.

KABIR: What is going on?

JENNY: Nothing…

MARGARET: It's not for me to say – Jenny should tell you.

KABIR: You must be telling me now. I am demanding you to tell me.

MARGARET: Really – it's best if it comes from Jen.

JENNY: Oh thanks, Gran.

KABIR: TELL ME!

JENNY: I was going to get around to telling you in my own time but, since my hand has been forced… They are definitely closing the church and going ahead with the sale.

KABIR: No.

JENNY: I had heard talk before…I didn't think it would come to this but they're selling it…to a health club… going to convert it into a new fitness studio.

KABIR: No.

JENNY: I'm afraid it's true.

KABIR: And the gardens?

MARGARET: A swimming pool.

KABIR: The graves?

JENNY: Will be fenced off.

KABIR: But the petition?

JENNY: They ignored it.

KABIR: All gone? Everything finished? How long have you known?

JENNY: I only found out yesterday.

KABIR: Yesterday?

KABIR thinks for a moment longer and then exits.

JENNY: (*Calls out.*) Kabir! Please...

MICHAEL: I'd better see if he's alright.

MICHAEL follows KABIR.

JENNY glowers at her grandmother and then storms out in the opposite direction.

MARGARET: (*Smiles.*) Oh dear, I think I'm in the dog house.

She exits slowly. SEBASTIAN is left on his own on the stage. He notices a Bible that MICHAEL has left behind. He picks it up and opens it. Reading the inscription on the inside cover he looks delighted.

SEBASTIAN: Yes!

Scene 5

It is late afternoon. MICHAEL paces anxiously. He looks at his watch from time to time. KABIR staggers in, swaying. He is swigging whiskey from a bottle and looks quite drunk.

MICHAEL: I have been looking for you everywhere. I waited for you here for hours. Where have you been?

KABIR deliberately pisses all over his precious orchids.

(*Horrified.*) Kabir!

KABIR: Go away, Mikey.

MICHAEL: Your orchids!

KABIR: Fuck 'em. They are closing this place down. All my work.

MICHAEL: You can rebuild this place somewhere else.

KABIR: I have made this my garden of paradise, a place for the people who have loved ones buried here. Somewhere they can walk and think and be on their own. It's going to be flooded. It's going be a swimming pool.

MICHAEL: I am sorry.

KABIR: Why was I bothering?

KABIR starts to kick his plants and flowers.

MICHAEL: Don't do that…

KABIR: What is being the point of these plants?

He continues to kick the plants.

MICHAEL: Please, stop it, Kabir.

71

KABIR picks up a tub of flowers and hurls it across the garden.

What are you doing? Stop it…they are your plants…

KABIR: Better I destroy them than they are drowned.

MICHAEL tries to stop KABIR. KABIR almost fights MICHAEL off.

Leave me alone!

KABIR gets into a wild rage, uprooting things and throwing things around. MICHAEL tries to stop him.

MICHAEL: Kabir, don't do this…they can be saved…you can replant them somewhere else…

KABIR: (*Shouts.*) Replant? Where? Where am I going to be now? Nowhere!

MICHAEL tries to stop him again but KABIR is strong and flings him off.

This is being my punishment.

MICHAEL: Sit down and take rest…you have drunk too much.

KABIR: Jenny was not even telling me.

MICHAEL: She was afraid – I think she was trying to find a good moment.

KABIR: My life is being finished. What am I doing this all for? I have been rebuilding for what? I was thinking I could live out the rest of my days here.

MICHAEL: These things happen my friend. We are merely guests in this country and we have to get used to being moved around a little.

KABIR: It is Satan. He is playing with me. He is pushing me like he was doing before.

MICHAEL: There is no devil here.

KABIR: I am the Devil.

MICHAEL: Now you are being ridiculous.

KABIR: You are seeing terrible things, Mikey but you are not doing them. Not like me.

MICHAEL: What are you talking about?

KABIR: I am an evil man saturated in my wife's blood.

KABIR slumps and sits down on the ground. He is broken hearted.

My Nusrat...

We hear the distant sound of men shouting, gunshots and screaming. KABIR points. He looks terrified.

The Indian soldiers, they have come to loot our village. Houses are on fire! They say we are hiding the separatists but we are innocent.

The gunshots get closer. KABIR relives the moment. He is in a panic. He scurries around looking for a hiding place.

They are coming...Nusrat...give me the baby...they are coming here...hide...we must be hiding. Quick...out here...they have guns...they will be shooting us...

KABIR hides behind a small shrub. He is clutching an imaginary child in his arms. The gunshots and shouting stop. There is total silence. KABIR watches with horror. We hear the same screaming we heard before. Nusrat's voice calls out KABIR's name, but he remains where he is.

They are raping her. Four soldiers…they take it in turns and I am watching. I am watching, covering my child's eyes and ears with my hands, squeezing her so tight to me – afraid she will call out. I am watching with these eyes of mine and I am not saving her. I can feel he is sitting behind me.

MICHAEL: Who?

KABIR: Satan. He is watching and smiling. I can be hearing him. He is saying, 'Stay where you are.' And I am being stuck to the spot.

They are strangling her and I can be seeing the life squeezed and squeezed from her face, they are pressing harder and harder on her soft throat…and then the soldiers are leaving. As if they have finished their day's work and they must go home for dinner.

KABIR remains where he is for some moments. MICHAEL helps KABIR up.

MICHAEL: You did not kill her. You saved your daughter.

KABIR: I should have been saving my wife, I should have been giving my life for her. I can never be returning to my birth place, never facing my daughter because of the shame. What sort of a terrible man am I being?

MICHAEL: You did what you had to do to survive, to save your child. You are not evil.

KABIR: I am lost.

MICHAEL: If you think you have done wrong, you must hear what happened to me. Then we will be truly like brothers. Yes?

KABIR: You are not understanding. You have seen terrible things but you have not been sinning.

MICHAEL glances over at KABIR'S shed.

MICHAEL: Listen to what happened to me. At the beginning of the killings, I was living in the Kibungo area of Rwanda with my wife and our son.

KABIR: You are being a wronged man – a noble man. I am being the worst kind of coward.

MICHAEL: I understand your guilt my friend but don't let it eat you up. I have done much worse. We hid some friends in our chicken house at the bottom of our garden. A Tutsi family who had run from their land. A man, woman and their two small daughters. They were afraid. Every day the *interahamwe* militia were prowling the village looking for Tutsis. So we hid them.

KABIR: You see? Even in the terrible conditions of your land you still...

MICHAEL: Listen. Each day I went into the local town to fetch our food, the militia at the roadblock would stop and search me on the way back...

KABIR: Search you?

MICHAEL: To see I was not carrying any extra food. They knew there were only three of us in our family. They wanted to see if I was feeding anyone else. This went on for ten days. Each day, I would be more and more afraid. Do you know what a roadblock is?

KABIR shakes his head. MICHAEL gets up and paces. He arranges some bricks and stones in front of KABIR. KABIR watches him.

It is a pile of stones in the middle of the road – manned by drunk, mad *interahamwe* militia men. In order to travel down the road, you have to argue your way through them.

75

KABIR stares at the stones. MICHAEL beckons him forwards. KABIR stands. MICHAEL picks up KABIR's machete and squares up to KABIR aggressively. MICHAEL transforms himself into a militia man, spitting out questions.

Who are you? Where are you going? Where is your card motherfucker? Your identity card. If you are an *Inyenzi* you will die. All cockroaches will die. Do you understand? Give it to me. Show me your card – where is it? NOW.

KABIR looks afraid as MICHAEL viciously pushes KABIR around using the blunt end of the machete.

We know you *Inyenzi* have dug pits under your floors to bury our corpses. We will stamp the filth of the Tutsi cockroaches out of our country once and for all. Vermin! Rats! Snakes! We will kill you all!

How much money have you got? You can't get by unless you pay us. Any beer?

KABIR backs away. MICHAEL reverts back to himself.

Each time I went by, there would be a pile of bodies just off the road – Tutsis who had met their end at that roadblock. I often saw the killings and it was a truly terrifying sight – men covered in dried banana leaves – like traditional dancers –

MICHAEL dances – it is a traditional Rwandan dance. He sings and swings the machete around , bringing it down jubilantly on imaginary bodies. We hear the sound of men shouting and screaming coming from the shed. KABIR looks terrified.

On the tenth day, as I was returning home with food – they began to shout at me and kick me.

76

KABIR: Even though you were a Pastor?

MICHAEL: It meant nothing to them. They knew I was hiding a family – someone must have informed them. I thought I had met my end. They marched me back home and demanded I tell them where the Tutsi family was. Otherwise, they would kill me and my wife and children.

KABIR: What did you do?

MICHAEL: What could I do? I showed them to the chicken house. We hear the terrifying sound of children screaming as they are butchered. Broken eggs and blood everywhere. The screams of the family die out and it is silent.

KABIR: They were all killed?

MICHAEL nods.

Those militia men butchered that family? In cold blood?

MICHAEL: They said it had to be done. To rid our country of vermin. 'Go to work,' they said.

KABIR: Work?

MICHAEL looks down at the machete in his hand.

MICHAEL: As if they were farmers cultivating the land. They gave me the machete and told me to do it.

KABIR: No!

MICHAEL: They said if I didn't, they would castrate me in front of my family and they would all stand around and watch me bleed to death. I did as I was told to protect my wife and child.

KABIR: You murdered children?

MICHAEL: I killed to survive.

KABIR: How could you do it?

MICHAEL: I had no choice.

KABIR: You had a choice. To die bravely and with honour without blood on your hands.

MICHAEL: It is very easy to say such noble things when you are not faced with the situation that I was.

KABIR: No…no…you were a man of the cloth…how could you be taking a life? How could you be dealing with your conscience?

MICHAEL: I was a husband and father first. I knew that my refusal would not only lead to my death but then to the rape and mutilation of my wife followed by the hacking to death of my child.

KABIR: But that family…you hacked them to death!

MICHAEL: God is my witness – I did it to save my family.

KABIR: You shouldn't have told me.

MICHAEL: But I told you because – I wanted to ease your mind. You were torturing yourself. You are my friend.

KABIR: That family were your friends.

MICHAEL: What would you have done in my place?

KABIR is silent.

You cannot answer me, my friend, because you hid and I killed. Both of us did it to save our lives.

KABIR walks away devastated. MICHAEL calls out after him.

I am not evil. Do not think badly of me.

KABIR: What does it matter what I am thinking?

MICHAEL: It matters to me.

KABIR: What you are telling me, Mikey – I cannot be comprehending.

MICHAEL: I haven't told you what happened next.

KABIR: No more...

MICHAEL: Do you know what those militia men did after I had...I had...

KABIR: Butchered that family?

MICHAEL: They called me a traitor – said they had to teach me a lesson. They killed my wife. They spared me and Charles but he saw his own mother being...killed. They forced me to kill and then they still punished me – no mercy – no compassion...my wife...

MICHAEL weeps. KABIR hesitates and then returns to where MICHAEL is seated. He puts his arm around him.

Interval.

ACT TWO

Scene 1

KABIR is trying to tidy up the garden. He looks tired and upset. He is not making much headway and is slow.

JENNY enters. She stares around the garden in horror.

JENNY: God, what a mess – what happened?

KABIR ignores her. Instead, he continues tidying up.

Kabir – you okay?

Please, don't be angry. Come on, Kabir, we've been friends for too long.

KABIR: If we were being such good friends you should have been telling me the news to my face. You were being a coward – not telling me.

JENNY: I didn't know how to… I know how much this place means to you.

KABIR surveys the mess around him.

KABIR: Everything is spoilt.

He picks up the banana tree and tries to straighten it.

Nothing is the same. I don't think I can be starting all over again – from the beginning.

JENNY: We still have a couple of months, it's not as if they're throwing us out onto the streets. I don't know where they're sending me yet but as soon as I do – I can make sure you have a job…

KABIR: (*Angry.*) This is not just my job. I don't do this because I am simply working. This is my life.

JENNY: I know… I know…

KABIR: You don't know. You and I are living in very different worlds.

JENNY: Kabir – please.

KABIR: No. Don't be pretending. To you – I am like a servant.

JENNY: How can you say that?

KABIR: You have never been suffering. How can you be giving comfort to people when you have never been in any bad situation? You are living in a cocoon where everyone is being 'nice' and giving charity to all those poor little starving black babies in the 'third' world.

JENNY: Stop it.

KABIR: And I am being another black bastard you are using.

JENNY: How dare you?

KABIR: You are collecting money in your church to ease your own little conscience when it is your Church that caused the fuck ups in those countries in the first place!

JENNY: Don't take it out on me. You don't have the monopoly on loss.

KABIR: Jenny, you are not knowing what it is like to live without hope – to know the things I am knowing. Every way I am turning, I am seeing more and more suffering. However far I run, I cannot be hiding anymore.

JENNY: There's nothing to hide from. You must stop blaming yourself. What happened to your family, to Nusrat is enough to drive anyone mad. But it wasn't your fault.

KABIR: It was his fault.

KABIR points heavenward.

Too many people suffering everywhere. Too many wars and too much cruelty. How are we supposed to live? To be knowing what is good and bad when all we are being shown is evil.

JENNY: But for every evil there is good. The world is an ugly place but...

KABIR: What are you knowing about the ugliness of the world? You sit here in your safe little world of Jesus Christ – preaching to the brainwashed. What would you be doing if you were being faced with danger? How would you be reacting if your whole town was being looted and burnt to the ground by soldiers?

JENNY: I don't know.

KABIR: Your God is being rubbish. He is, as Ayesha would say, a 'fucker'. I should have been listening to my head and taking revenge.

JENNY: No. Revenge doesn't work. It never has. It simply keeps the hatred alive.

KABIR: So when will I ever be having any peace, Jenny? When will I be free?

JENNY: When you learn to forgive yourself.

KABIR: I cannot forget.

JENNY: No – but you can live and move on, Kabir. This is just a patch of earth.

KABIR: Then I am choosing the wrong patch of earth. It is being a place for the dead.

JENNY: Maybe you're right. Maybe we should all get out of here.

JENNY looks at KABIR sadly.

KABIR: If I am staying here. I will be living in hell forever afraid of being lured into the Devil's nest.

JENNY: We're all one step away from the Devil's nest.

KABIR: Some of us are being closer than others though.

MICHAEL: Ah…Jenny…Kabir.

MICHAEL looks over at the bench and then beneath it.

JENNY: What are you looking for?

MICHAEL: My Bible. I thought I left it here… Have you seen it?

JENNY: No…

KABIR shakes his head.

Was it very precious?

MICHAEL: It is from home. I cannot remember where I last had it. I always carry it around with me.

JENNY: I'll ask around for you.

MICHAEL: No…it's fine…it was a battered old thing.

MICHAEL continues to look worried.

JENNY: Did it have your name in it?

MICHAEL: Erm…no I don't think so. Actually, it belonged to an old friend…it doesn't matter…perhaps it will turn up.

MICHAEL exits hurriedly.

KABIR: I was being a peaceful man. I offered prayers to Allah five times a day and I was working hard for my family. The soldiers and the separatists were all using us in their battle for our land. We were being innocent.

I am wanting to be seeing my daughter. She is almost a woman now and all I have are photographs. It is not being the same thing.

I am thinking I should be going home. My brother is living in Delhi now. He has a new job as a school head teacher. He was always the clever one…maybe the school is needing a gardener.

The two sit in silence for a while.

JENNY: You have been my rock, Kabir. The one point of sanity in my life.

KABIR: And you have been helping me in so many ways.

JENNY: When I lose this church, I'll lose you. Maybe that's why I couldn't bring myself to tell you. I find the thought of not seeing you every day almost as unbearable as leaving this place.

KABIR: (*Smiles.*) I am just being the gardener, Jenny. A heathen, a non-believer, a foreigner.

KABIR takes JENNY's hand and kisses it. They laugh. MICHAEL enters. He looks worried.

Scene 2

The sun is setting. A party is going on. Loud reggae music is playing and SEBASTIAN is dancing, can of beer in one hand. MICHAEL is choosing tapes for the ghetto blaster. AYESHA is stringing some fairy lights up. AYESHA drapes them across some grave stones.

KABIR: Isn't that being disrespectful?

AYESHA: They're hardly gonna complain.

KABIR looks uncomfortable.

Take a chill pill, Kabir.

SEBASTIAN: Yeah, ease up man. Loosen your collar…enjoy…

KABIR: She should be revising.

AYESHA: Give me a break.

KABIR: Maths tomorrow. You must be having a clear head.

AYESHA: I'll just stay for a bit.

SEBASTIAN: Ignore him. Stay for as long as you like.

KABIR: You are being a bad influence.

SEBASTIAN: Believe me, I'm the least of your worries.

AYESHA: I was thinking Kabir, after this place has closed – you should advertise your services locally. Lots of people need gardeners.

KABIR: I am thinking maybe…

AYESHA: The toffs up the hill have got huge gardens. You could mint it.

KABIR plugs the lights in. AYESHA claps her hands in delight.

It's like Christmas.

KABIR: Now all we are needing is a turkey.

MARGARET enters. She is clutching a bottle of vodka and some tomato juice.

MARGARET: Looks lovely dears.

She looks around at the plants etc. all in dissaray.

This place is a bit of a mess though.

MARGARET waves the bottle at KABIR.

My contribution. Thought we could have some Bloody Marys.

AYESHA grabs the bottle and looks at it.

AYESHA: Excellent.

KABIR grabs the bottle from her.

KABIR: You are not drinking any of this.

AYESHA: Come on…just one.

KABIR: No.

AYESHA: Fascist.

KABIR: You will be having one drink, getting sick, falling asleep and then not getting up for the examination.

AYESHA: Think I'm that green?

MARGARET: If you want to pass your exams and travel the world, tonight you'll have to stick to Virgin Marys, my dear.

AYESHA sulks. SEBASTIAN has a little dance around pulling MARGARET gently around with him. She laughs and does a little twirl. The others watch. JENNY enters carrying a tray of glasses and a couple of bottles of wine.

JENNY: Can't imagine why we're doing this. Don't exactly feel in the celebrating mood.

SEBASTIAN: I think it's a great idea.

MICHAEL: The end of an era.

SEBASTIAN: Exactly.

JENNY arranges the glasses on the table.

JENNY: Can't concentrate on my sermon. Keep getting these visions in my head of sweaty men pumping iron in the pulpit.

MARGARET: Sounds rather like a sexual fantasy to me.

JENNY: Gran!

MARGARET: At least the place'll be packed, Jen. Probably have more people in it than it's had in a century. The new temple to the human body.

KABIR gets to work uncorking the wine and handing out glasses. SEBASTIAN cracks open a can of beer and gives one to AYESHA. He's unsteady on his feet.

SEBASTIAN: Get that down you girl.

KABIR: (*Warning.*) AYESHA!

AYESHA: It's only beer.

AYESHA takes a swig under KABIR's watchful eye.

JENNY: Five thousand graves. Nobody's thought about what will happen to them.

MARAGRET: Stop worrying about the graves.

JENNY: But I do worry. Who's going to look after them? Once Kabir's gone, the graveyard will become overgrown.

SEBASTIAN: Forgotten bones.

JENNY: Come on then, Sebastian. One last photo. You got your camera on you?

SEBASTIAN: Sure.

MICHAEL looks at his watch

MICHAEL: I cannot stay too long…

JENNY: One last photo of everyone. For my album.

JENNY herds everyone into a group. They all do her bidding except MICHAEL who stands aside.

KABIR: Mikey – please.

Everyone calls MICHAEL over. He joins them reluctantly. SEBASTIAN sways as he tries to focus.

Smile!

False smiles all round.

Look at the mad man – he cannot even be standing straight.

MARGARET: I think we should at least drink a toast.

SEBASTIAN: A good idea.

SEBASTIAN makes sure everyone has a glass.

KABIR: Go on, Jenny.

JENNY: Me?

SEBASTIAN: (*Heckles.*) Remember it's a toast not a prayer.

JENNY: Thank you for reminding me, Sebastian.

They all laugh and stand to attention with their glasses and look at JENNY expectantly.

Well…erm…to all of you, thank you for standing so close over the past few weeks. It's been…difficult. But all good things must come to an end and we must leave our lovely Garden of Eden, I'm afraid.

JENNY looks at KABIR. They smile sadly at each other.

Anyway. Raise your glasses – to a brighter and happier future.

ALL: The future.

AYESHA downs her drink in one.

KABIR: Another one.

SEBASTIAN refills everyone's glasses.

This has been my home for nearly ten years now. I have been making good friends when I was losing everything. I am wanting to thank you all and to be saying don't be becoming a stranger. And good luck to Ayesha in her exams. Bottoms up!

ALL: Cheers.

SEBASTIAN: Anyone else?

SEBASTIAN looks around at everyone. MICHAEL makes a toast.

MICHAEL: This place has been very special. You have all been like a family to me.

MARGARET: Very strange one.

MICHAEL: You will all remain in my heart forever. Thank you.

Everyone raises their glasses and drinks.

I am sorry. But now, I must leave.

KABIR: Already?

MICHAEL: I have to pack. Tomorrow I leave – a little trip to see a friend.

KABIR: But we haven't even been starting the party yet.

MICHAEL: I'm sorry…

KABIR: You were not telling me you were going away.

MICHAEL: It was a last minute thought.

SEBASTIAN: Where are you going?

MICHAEL: The States.

MICHAEL embraces KABIR affectionately.

I will be in touch my friend.

KABIR: Don't be disappearing.

They hug for some time. When they part – SEBASTIAN produces a Bible from his pocket. He shows it to MICHAEL.

SEBASTIAN: I think this belongs to you.

MICHAEL: My Bible…ahh…thank you.

SEBASTIAN opens the Bible and reads the inscription.

SEBASTIAN: (*Reads.*) Pastor Samuel. Friend of yours was he?

MICHAEL: Pardon?

SEBASTIAN: Pastor Samuel.

MICHAEL: I knew him. Yes.

MICHAEL shakes hands with JENNY.

Goodbye, Jenny.

JENNY: Take care, Michael.

MICHAEL: Thank you for everything.

MICHAEL turns to leave but SEBASTIAN catches hold of him.

SEBASTIAN: Don't you want your Bible?

MICHAEL: Yes…thank you.

But before MICHAEL can take the Bible, SEBASTIAN holds up the Bible above his head. He transforms himself into a preacher.

SEBASTIAN: The Tutsi are foreign to the area and have stolen Rwanda from it's rightful inhabitants…

AYESHA: What's he on?

SEBASTIAN: I am your pastor. Listen to me. I am giving you the word from God himself…

MICHAEL: (*Upset.*) No…no…

AYESHA: He's pissed.

SEBASTIAN: Let us finish off these Tutsi cockroaches once and for all. If we don't, they will kill us. They have prepared holes in the dirt floors of their houses to dump your Hutu corpses – yes – even your neighbours and so called friends…

KABIR: Stop it.

SEBASTIAN: Do you know who this man is?

KABIR: Sebastian…

SEBASTIAN: This wolf in sheep's clothing ordered others to kill.

KABIR: You are being ridiculous.

JENNY: Sebastian – please…

SEBASTIAN: He ordered over five thousand killings.

AYESHA: Seb man… calm down.

SEBASTIAN: I know what I'm talking about. I have a photo to prove it.

SEBASTIAN scrabbles around in his pocket and pulls out a crumpled photo. He shows it to JENNY.

The Church in Kibungo. I took it myself.

JENNY: Sebastian…it's just a photo of a Church.

SEBASTIAN: This is Kibungo where Pastor Samuel lived and worked. He was killed. Why does Michael have his Bible?

MICHAEL: He gave it to me.

SEBASTIAN: I was there – in Rwanda. I took photos of the carnage…the pastor…he was the one responsible.

KABIR takes a firm hold of SEBASTIAN and tries to pull him aside.

KABIR: You have been drinking too much again. Go. Mikey. Go.

MICHAEL turns to go but SEBASTIAN calls out.

SEBASTIAN: His name isn't Michael. It's Charles Bagilishema. I've been looking for him for eight years… I've finally nailed him.

MICHAEL: You have the wrong man.

SEBASTIAN: Tell them the truth. Tell them what you did.

MARGARET: What did he do?

MICHAEL: Don't listen to him.

SEBASTIAN: Herded them into the church…innocent people…brought the killers…handed out machetes…Kibungo…the Church…

JENNY: Sebastian, stop this nonsense right now. You're imagining things.

SEBASTIAN: It was unspeakable what his kind did…

MICHAEL: No – not me.

SEBASTIAN: My people – my ancestors – people I honoured and respected – capable of such depravity. Children in the classroom, their arithmetic still chalked up on the board, mothers with their babies hacked to pieces in their arms, pregnant women with their wombs ripped out…and no one cared. No one did anything.

KABIR: You have seen too much. It has turned your mind.

SEBASTIAN: One million people killed in hundred days. Africans killing Africans and the world stood back and watched. Why? Because our sorry black faces aren't worth shit to them.

MICHAEL: He's gone mad.

SEBASTIAN: How many people did you kill personally? Ten? Twenty? One hundred? Two hundred?

MICHAEL: I am innocent. I committed no crimes. These accusations are monstrous. I lost my own son. I hid in the bushes. I was hunted.

SEBASTIAN: Because you were running away.

MICHAEL: I am innocent.

SEBASTIAN: So, go back and prove it.

MICHAEL: They won't believe me. There is so much suspicion in my country – it only takes one person to point the finger and you are thrown into prison. People die waiting for a trial – there isn't enough room – they can't even sit down. There are children in there too accused of crimes. There is no justice in my country. No truth, no dignity, only accusations and more killings. I am not a murderer.

KABIR: Go home, Seb, and be sobering up.

AYESHA: Please, Sebastian. Stop it.

SEBASTIAN: He's lying. I know who he is.

MICHAEL: You are the one lying. Everyone here knows me. How could I do such terrible things? I lost my son.

SEBASTIAN: Because you were running away.

MICHAEL: No!

SEBASTIAN: Admit it.

MICHAEL: No!

SEBASTIAN: I spoke to witnesses. They saw him in his truck handing out weapons and giving orders…people

he left for dead, who hid in fear under the bodies of their dead mothers, fathers, sisters, brothers, children… I went in search for him…

MICHAEL suddenly becomes angry and turns on SEBASTIAN.

MICHAEL: You don't frighten me. Trying to make a name for yourself, eh? Failed – drunk? There is no evidence.

SEBASTIAN: There are witnesses…

MICHAEL: So you keep saying but anybody can say they saw anything. They are government tools – if they don't say what the new government wants, they'll be killed. And you are a government spy.

SEBASTIAN: Admit it.

MICHAEL: Never. Never. Never. I never told anyone to kill people. I could not do such things.

SEBASTIAN: You were a pastor.

MICHAEL: I admit that – yes. And what I saw in my country made me question my belief but now I am closer to God than I have ever been in my life. Hatred is the result of sin and it will only be taken away when Jesus Christ returns.

SEBASTIAN: Don't get biblical with me.

MICHAEL: It wasn't me. You have the wrong man. I am not Charles Bagilishema. I am Michael Ruzindana – I did not kill any people – it is all one hundred per cent lies.

SEBASTIAN: And this Bible – is it one of the mementos you kept hold of? A trophy? Wasn't Pastor Samuel one

of the people you killed? Didn't he write a letter to you, begging you to save the congregation's life? And how did you answer that letter?

SEBASTIAN holds up the Bible above his head again.

Rise up, Hutu brothers. Rise up in self defence. The graves are only half full! There is a new Commandment – if you are struck on the cheek once, you must strike back twice. Now, pick up your tools and go to work.

JENNY looks at MICHAEL – suspiciously. MICHAEL turns and tries to leave.

SEBASTIAN however, tries to stop him. The two men wrestle. In the struggle, bottles of wine and glasses are knocked over.

MICHAEL is desperate as he punches and kicks. He slips out of SEBASTIAN's grasp and runs away. SEBASTIAN turns on KABIR.

You know the truth. How can you protect him?

KABIR is rooted to the spot. He looks unsure.

SEBASTIAN looks disgusted and runs out after MICHAEL.

Scene 3

It is later. KABIR has lit a lamp by the tree and is digging. As he digs, he keeps looking around to see that no one is there. Eventually, he hits something hard. As he scrabbles around in the dirt, he pulls up an old cigar box. He sits on the bench and opens it carefully. He hesitates and then examines the contents. He pulls out papers. Some of them crumble in his hands. Some remain intact. He reads them. He pulls out an old passport and examines it. There is a rustling in the tree. KABIR hides the box, stands up and looks up.

KABIR: Who is there?

The rustling continues. KABIR picks up his machete for protection.

Come down here at once.

A small bag is thrown down and MICHAEL clambers down after it. He looks afraid.

Mikey!

MICHAEL: They are after me – they came to my house.

KABIR looks around him. He puts the machete down.

KABIR: Who?

MICHAEL: The Police! Sebastian must have gone to them.

KABIR: But surely they will be looking for you here.

MICHAEL: (*Desperate.*) I need somewhere to hide.

KABIR: You are thinking you can still be selling me all your lies? You think I am being stupid?

MICHAEL: People make mistakes. You have known me for five years. Have I not been a good friend to you? We have shared joy and laughter together.

KABIR: People make mistakes but five thousand lives…

MICHAEL: I did not do those things. But it is not safe for me in Rwanda. You mustn't let them take me – hide me – in the church.

KABIR: I can't…

MICHAEL: Then hide me somewhere else – just for tonight. Tomorrow I can get to some friends – they can conceal me, take me out of this country. Then I will bother you no more. I will change my identity, I will vanish.

KABIR looks helpless.

(*Panicked.*) You must hide me. You are my friend. I have trusted you. Hide me in your shed. Please.

Seeing he is getting nowhere, MICHAEL takes a pouch from his pocket.

Look, take it, it's yours.

MICHAEL holds up a diamond.

It is very precious. A diamond.

KABIR: (*Disgusted.*) I don't want it.

MICHAEL tries to force the diamond into KABIR's hand but KABIR turns away.

MICHAEL: It is worth a lot of money. A rich man gave it to me when I was fleeing persecution through Zaire.

KABIR: You were the persecutor.

MICHAEL: It will mean certain death for me if they take me back. They hate the Hutus – they plan to kill us all. They won't give me a fair trial – they took our land from us before, forced us into slavery and servitude – they will do it again. I can't go back there.

KABIR: You must be facing up to your sins.

MICHAEL: Will you help me?

KABIR: If I am truly being your friend, then I want to be hearing the truth from you.

MICHAEL: I have told you the truth.

KABIR: You haven't.

MICHAEL: I harmed no one. Why don't you trust me?

KABIR: You are still lying! I know you have killed to be saving your family.

MICHAEL: And I know *you* have stood back and allowed your wife to be killed.

KABIR looks away – hurt.

I did not want to leave without saying goodbye. I will trouble you no more.

MICHAEL turns and walks away.

KABIR: (*Calls out.*) Come back. I will be giving you shelter for the sake of our old friendship – if you are telling me the truth. Is it true what Sebastian is saying?

MICHAEL stops and hesitates.

Well?

MICHAEL: No. He has the wrong man.

KABIR produces the cigar box from its hiding place.

KABIR: I was finding your real passport – with your real name – Charles Bagilishema. It is having your photo.

MICHAEL: You dug it up?

KABIR: You were making a fool of me. I was thinking, this was in the memory of your boy. Were you even having a son?

MICHAEL: Yes.

KABIR: And was he really dying?

MICHAEL: They were after us. Hunting us like animals. We had to hide in the bush – there was no food. I tried to feed him with grass but it was no good. I could not keep him alive. He was only eight years old.

KABIR: Who were you running from?

MICHAEL: The enemy.

KABIR: Who was being the enemy?

MICHAEL: The army.

KABIR: Whose army?

MICHAEL: The Tutsis.

Beat.

KABIR: And they were hunting you because you had been killing Tutsis.

MICHAEL: So they said.

KABIR: You must be telling me the truth. If you are wanting shelter for tonight – otherwise I will be calling the police.

MICHAEL: No.

KABIR: Were you killing those people in the church?

Beat.

MICHAEL: I had no choice. Truly. The militia wanted me to help them. Every day, they came to my house, they threatened me. They had already slaughtered my wife. They kept saying that if I did not help them, they would do the same to me and Charles. I was afraid. I had to live on my wits – to save my son's life. Violence feeds on violence, like a fire. People went mad and killed and killed and killed.

KABIR: You were the pastor in your district, surely you could have stopped it?

MICHAEL: No one would listen to me. I tried to resist at first, to reason, but there was a kind of madness, chaos…and I began to think, if it wasn't my turn today, it would be my turn tomorrow. Kill, so as not to be killed – that was my motto.

KABIR remains silent.

Everyone was spying on everyone. Peasants were killed because they refused to beat the dead bodies of their Tutsi neighbours. Even my son wanted to stand at the roadblocks and help with the killing. I would not let him go but he said, 'Father, at least I can help kill the little ones.' It was like a poison that spread through my body so fast, I didn't even realise how sick I had become…

KABIR: How many people were taking refuge in that church?

MICHAEL: About three thousand. I told them to go there…that it would be safe for them. I believed they would not be harmed – that God would protect them. And then I received my orders.

KABIR: To be killing them?

MICHAEL: To kill them all. Hobble the children first. Slash their Achilles tendons so that they could not move far. Then the parents would come running to protect them…those were my orders. It took four days and nights. When the dogs heard the cries of the people. They too began to howl.

MICHAEL closes his eyes.

KABIR: How many people were you killing personally, Mikey?

MICHAEL: I don't know.

KABIR: How many?

MICHAEL: I lost count. One hundred? Maybe two hundred?

KABIR: (*Incredulous.*) You were losing count? And how many children?

MICHAEL: Only those two, in the chicken house. I never killed children after that.

KABIR: You were leaving that to the others?

MICHAEL is silent.

What were you doing with their bodies?

MICHAEL: They were thrown into mass graves.

KABIR: Were there prayers being said over the graves?

MICHAEL: (*Ashamed.*) No.

KABIR: And those people in the Church – you were ordering their killings?

MICHAEL: I was forced to do it. The leadership, they told me that if I didn't prove my Hutu solidarity – they would come after me. Don't you understand? – it was a war – and I had to take sides otherwise I would have been killed.

KABIR: Is your life really being so important?

MICHAEL: It is to me. You don't understand my country – the Tutsis were our enemy. For years they looked down on us – treated us like slaves. This was a situation waiting to happen. It was a coming together of the

people against their oppressors. One hundred days of vengeance.

KABIR: And the children? The babies? Were they also being your oppressors?

MICHAEL: One day, they could grow up to be so.

KABIR: How many women were you mutilating?

MICHAEL: None.

KABIR: I was reading stories of pregnant women's wombs being ripped open to get at the unborn foetuses. Were you doing that too?

MICHAEL: No!

KABIR: But you must have seen it happening?

MICHAEL: Once or twice – but not by me.

KABIR: But you gave the orders.

MICHAEL is silent.

How are you sleeping at night? Aren't the voices of your victims calling out to you in your nightmares?

MICHAEL: I am human, with all the failings that come with it. But surely, I deserve another chance – to prove myself a worthy man.

KABIR: What about the people you are killing? What chances do they have now?

MICHAEL: They were Tutsis. They stood no chance of survival in that country at that time.

KABIR: And you think I should be helping you? Aren't you being ashamed to be breathing? To be surviving?

MICHAEL: Ashamed? Yes. But then I think, God must have singled me out for a purpose.

KABIR: What purpose?

MICHAEL: To show mercy on my soul.

Beat.

KABIR: Did you rape the women?

MICHAEL is silent.

Did you?

MICHAEL: We had to be seen to show no mercy. The Tutsi women were part of the problem – they had used their feminine wiles to dilute our Bantu blood. They had to be dealt with, punished, humiliated.

KABIR: Tortured.

MICHAEL: Their men ran away. They did not protect them. They hid or sacrificed their wives to us to do as we pleased.

KABIR: You are an animal.

MICHAEL: We were at war. And in war, gang rape is more effective than any military weapon.

KABIR struggles to maintain his calm.

KABIR: If I were being a Tutsi – you would have been killing me too, to save your own skin? Would you be raping and killing my wife and daughter?

MICHAEL does not answer. KABIR picks up the machete. He brandishes it menacingly. Suddenly, KABIR looks frightening.

(*Shouts.*) Now I am a Hutu and you are a Tutsi.

MICHAEL cowers and tries to protect himself with his hands. KABIR aims the machete at MICHAEL's head.

MICHAEL: (*Frightened.*) No…please Kabir.

KABIR: I am seeking vengeance for all those people you killed.

MICHAEL: (*Screams.*) Please.

KABIR: Who will be mourning your death here? No one. Who will care? No one.

KABIR raises the machete deliberately over MICHAEL. MICHAEL tries to run but KABIR chases after him with the machete. MICHAEL trips and falls. KABIR is screaming and shouting.

Vengeance is mine!

MICHAEL collapses to his knees and clings to KABIR's feet weeping and sobbing. KABIR hesitates – machete poised mid-air.

MICHAEL: Please I beg you, don't…don't… (*Babbling a prayer.*) Almighty and most merciful Father, we have erred and strayed from Thy ways like lost sheep… We have offended against thy holy laws… O Lord, have mercy on us miserable offenders.

KABIR pulls roughly away from MICHAEL leaving him kneeling on the ground praying feverishly to himself.

And grant, O merciful Father, that we may hereafter live a godly, righteous and sober life, Amen.

KABIR brings the machete down with all his force on MICHAEL's arm. MICHAEL's arm is hacked off. Blood gushes out across the floor. MICHAEL looks at his severed arm in disbelief and screams with agony.

KABIR: An eye for an eye, a tooth for a tooth.

MICHAEL crawls away begging all the time. KABIR prowls after him.

MICHAEL: No, no…Kabir…we are friends…don't do this…you said you would help me…no…no…

KABIR picks MICHAEL up by the scruff of the neck and drags him backwards towards the shed. MICHAEL is screaming all the way. As the shed door is shut behind him we hear the blood curdling screams for help coming from MICHAEL and the sound of a machete. Night descends. In the darkness, we hear the roar and crackle of a huge fire.

Scene 4

As the dawn rises, we see the shed has disappeared. Instead there are the smouldering ashes of what has obviously been a raging fire. KABIR sits on the bench beside the shed. He looks shell-shocked and is silent. His face and hands are covered in soot. MARGARET is sat next to him. She is comforting him.

SEBASTIAN enters. He looks at the shed and then at KABIR. He looks aghast.

SEBASTIAN: What the hell happened here?

KABIR remains silent. MARGARET looks at SEBASTIAN as if the question is rather obvious.

Kabir? What happened to your shed?

MARGARET: Burnt to a cinder. Vandals I shouldn't wonder.

SEBASTIAN: Someone's got it in for this place.

JENNY enters. She is in a flap.

JENNY: I've called the fire department but I told them there's no point really – it's all burnt down now. They said that as long as there's no danger, they'll send someone along later this morning to have a look. I'm so sorry, Kabir.

MARGARET: It's very bad luck.

SEBASTIAN: Michael got away. The police couldn't find him at his house. He probably never went home.

SEBASTIAN kicks the dirt floor in frustration.

Can't believe I fucking lost him.

KABIR: He came here.

SEBASTIAN: Last night?

KABIR: Yes. He wanted me to hide him.

SEBASTIAN: (*Angry.*) You should have turned him over to the police. Why didn't you call me?

JENNY: Where did he go?

KABIR: Not far.

SEBASTIAN: Where?

KABIR: Where we cannot be finding him.

SEBASTIAN: (*Angry.*) I hope you realise what you've done man. Where did he go? Did he tell you?

KABIR remains silent and withdrawn.

JENNY: What did he say to you?

KABIR: He confessed.

JENNY: Confessed what?

KABIR: His name was Charles, not Michael.

KABIR produces the passport with MICHAEL's photo. JENNY and MARGARET examine the photo. SEBASTIAN takes the passport and scrutinises it.

MARGARET: So, Sebastian was right.

SEBASTIAN: Only, none of you would listen…and now, God knows where he's gone. (*Anguished.*) Man! I found him. After all this fucking time –

SEBASTIAN does a double take and looks at the smouldering ashes of the shed. He can just make out the charred remains of a human body.

Jesus Christ.

JENNY: What?

SEBASTIAN points at the remains. JENNY walks over and looks.

MARGARET: What is it, Jen?

JENNY groans. She covers her mouth and rushes to the corner. She wretches. MARGARET stays where she is. SEBASTIAN inspects the remains.

KABIR: That is being Mikey. He was wanting somewhere to hide.

JENNY: You hid him in the shed? Is that it? And some vandals broke in?

MARGARET: What happened here last night, Kabir?

KABIR is silent. JENNY looks horrified.

JENNY: No…this can't be true. Kabir? What have you done?

KABIR is silent.

Kabir?

KABIR: He was thinking I would be helping him to escape. That he could be forgiven just by praying.

SEBASTIAN: Is this for real? Is that Michael? I've searched for him for eight years and you...you've just murdered him?

I was going to take him back, to face his accusers. What about justice?

JENNY: Justice has been done.

SEBASTIAN: How can you say that?

JENNY: He would have been executed anyway or he would have rotted and died in jail.

SEBASTIAN: But we have no right to act as judge and executioner. What about the survivors? The families of his victims?

JENNY: This isn't about them, it's about you. Thought you'd get a best selling book out of it did you?

SEBASTIAN: People deserve to know the truth.

JENNY: You would have basked in some of the glory though wouldn't you? Made a tidy sum.

SEBASTIAN: He was a criminal, he had to be held to account.

MARGARET: He's been punished. What more do you want?

SEBASTIAN: As long as he was alive he would have suffered but now...he's been released.

KABIR: He was suffering.

SEBASTIAN: What gives you the fucking right? How could you do this?

KABIR: He was evil.

SEBASTIAN: So what does that make you? Jesus. Jesus Christ. You burnt him alive?

KABIR: He is dead. That is all you are needing to know.

SEBASTIAN: I haven't been able to sleep properly for eight years. Every time I close my eyes I see those people, their faces, those kids in their classroom…
I could have taken him back to face the families whose lives he devastated.

KABIR: He was being my friend. Only I could be punishing him.

SEBASTIAN: He confessed?

KABIR: Everything.

Beat.

MARGARET gets up.

MARGARET: (*Urgent.*) We've got to get rid of it – before the fire department arrive.

MARGARET fetches a couple of spades and hands one to JENNY. Without a word, MARGARET starts digging a shallow grave beneath the tree. SEBASTIAN and JENNY watch her confused.

JENNY: Gran? Waht are you doing?

SEBASTIAN: We should go to the police.

JENNY: We can't cover this up.

MARGARET: Yes we can. All of us protected Michael. You took him under your wing.

JENNY: I didn't know…how was I supposed to…?

MARGARET stops.

MARGARET: Look at him, Jen.

JENNY: I can't be seen to condone this.

MARGARET: So, we just stand back and wash our hands? We're all culpable.

JENNY: No.

MARGARET: For once in your life, Jen, will you please listen to me? Look at him.

JENNY looks over at KABIR.

You want to ruin another man's life?

JENNY is torn.

I can't do this on my own.

JENNY picks up the other spade and helps MARGARET in her digging.

SEBASTIAN is upset.

SEBASTIAN: How are you going to get away with this?

KABIR: He was defending his actions. He was saying that he ordered people to kill and rape. He was killing children. He could not even be remembering how many.

SEBASTIAN: I wanted to hear him admit what he did. To my face. He said all this to you?

KABIR: Yes.

SEBASTIAN reluctantly takes the other spade and starts to dig. Between the two of them, they manage to dig a small pit. KABIR picks up MICHAEL's charred body and throws it down into the pit. SEBASTIAN goes back and forth collecting more bits and pieces of bones and finally the skull. As he puts it into the pit, KABIR smashes the skull with the machete and then collapses weeping. SEBASTIAN covers the grave up again with soil. He hesitates.

SEBASTIAN: Shouldn't you say a few words? A prayer, or something?

JENNY: If you want to say a prayer – be my guest.

SEBASTIAN hovers for a moment looking down at the shallow grave. KABIR produces the cigar box. He opens it and pulls out an old crumpled letter. He stands by the grave and reads.

KABIR: Pastor Samuel's letter. Our dear leader, Pastor Charles Bagilishema. How are you! We hope you will be able to come to our assistance. We wish to inform you that we have heard that tomorrow we will be killed with our families. We therefore ask you to speak up for us especially to the mayor. We trust that, with God's help who has placed you at the head of this congregation, which faces destruction, your mediation will be accepted with gratitude, just as the Jews were saved by Esther. We give respect to you.

JENNY supports KABIR and exits. SEBASTIAN stands by the grave, a while longer and then exits.

Scene 5

It is a bright sunny day. MARGARET is seated on the bench. She is dressed and ready to go out somewhere. AYESHA enters. She looks delighted and is on a high.

AYESHA: Ask me a question.

MARGARET: I beg your pardon?

AYESHA: Ask me a question. 'Was King Charles I a misunderstood monarch?'

MARGARET: What?

AYESHA: Go on, ask me…

MARGARET: Oh alright…was Charles I a misunderstood monarch?

AYESHA: I don't know – fuck off!

AYESHA giggles maniacally.

MARGARET: Well really!

AYESHA: No more fucking exams, no more lessons… that's the last time I ever have to walk into that miserable grey building with its arsehole teachers and their wanky lectures…

She pulls off her tie and throws it to the ground and stamps on it.

Last bloody time I have to write anything, ever about kings or queens or bloody useless, fucking novels. I'm free!

AYESHA dances around and laughs and skips.

MARGARET: I take it you've finished your exams. How did you do?

AYESHA: Who gives a fuck?

MARGARET: You know, you really are going to have to improve your language skills if you want to become an air hostess. Telling passengers to eat their 'fucking' breakfast isn't going to go down too well.

AYESHA comes up and hugs MARGARET and gives her a big kiss. MARGARET reels.

Steady on.

AYESHA: (*Emotional.*) I've been institutionalized all these years. It's like breaking free from prison. I've got the key in my hand and I've opened the door. Step out into the light and breathe the fresh air. My life begins today.

MARGARET: That's when the problems really start.

AYESHA: It's a fucking amazing feeling.

(*Emotional.*) Next week I'll be sixteen. I'm a grown up woman. It's my life and I'm going to live it.

AYESHA dances around the garden and bends down and looks at one of the few remaining flowers.

Hello, little flower, ain't you beautiful? Ain't you exquisite? Shining with the radiance of the fucking sunlight, oh and little banana tree, how small your leaves seem but one day you'll be able to poke your head up higher than that wall. Then they'll really notice you.

MARGARET: Kabir has gone.

AYESHA: Gone? What d'you mean?

MARGARET: He left this morning – moved in to his new place.

AYESHA: He never told me. Is he coming back?

MARGARET: I don't think so, dear.

AYESHA: Mean bastard. He could have rung me.

MARGARET: He probably couldn't face it.

AYESHA: He's really gone?

MARGARET nods.

He never even said 'goodbye'.

MARGARET: Jen got him a job in her new parish. Only difference is there's no garden, just a car park around the back of the church hall.

AYESHA: What's he going to do in a car park?

MARGARET: Hand out tickets I suppose.

AYESHA: Sounds like hell.

MARGARET: It's time to move on. Taxi should be arriving any moment to whisk me and Jen off to Dover. Apparently the vicarage where we'll be living has one of those electric stair lifts for me. Can't wait to use it.

AYESHA: You'll be up and down there like a bleedin' yo-yo.

MARGARET: Like Bette Davis.

AYESHA: Who?

MARGARET: Before your time, dear. Thought Jen might see sense and leave the church but no – she's addicted to it. It's like a very bad habit.

JENNY: (*Calls offstage.*) Gran! Taxi's here.

MARGARET: That's me. Good luck. Oh erm – Kabir left this for you. Apparently he found it in the shed – after it had burnt down.

MARGARET hands AYESHA the diamond.

AYESHA: Thanks. What is it?

MARGARET: A girl's best friend.

AYESHA looks confused. She holds it up to the light.

It's very valuable. Take my advice, run along to a jewellers and get it valued. Should be enough for you to see the world.

AYESHA looks in disbelief at the diamond.

AYESHA: You sure about that?

MARGARET: Certain.

AYESHA bends down and kisses MARGARET.

Bye, bye…

MARGARET waves and exits. AYESHA is left standing on her own. She looks at the diamond, chucks it in the air and catches it again. She smiles and exits.

The End.